The Campus History Series

GETTYSBURG COLLEGE

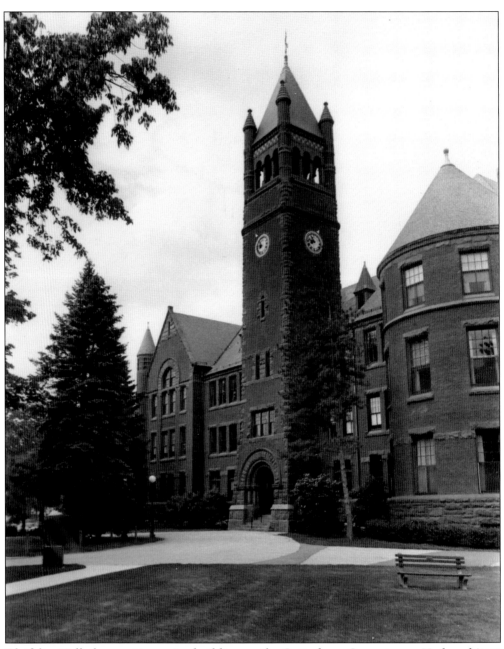

Glatfelter Hall, the most imposing building on the Gettysburg Campus, was York architect John A. Dempwolf's masterpiece. This view, taken more than half a century after the building was dedicated in 1889, captures some of its distinctive features. Known as Recitation Hall at its dedication in 1889, it served as home to most campus departments, the college's literary societies, and its library. It was renamed Glatfelter Hall in 1912 in recognition of the philanthropic support of the P. H. Glatfelter family.

On the cover: Please see page 30. (Courtesy of the special collections of the Musselman Library at Gettysburg College.)

The Campus History Series

GETTYSBURG COLLEGE

MICHAEL J. BIRKNER
IN COLLABORATION WITH DAVID CRUMPLAR

ARCADIA
PUBLISHING

Published by Arcadia Publishing
Charleston, South Carolina

Printed in the United States of America

Library of Congress Catalog Card Number: 2005938876

For all general information contact Arcadia Publishing at:
Telephone 843-853-2070
Fax 843-853-0044
E-mail sales@arcadiapublishing.com
For customer service and orders:
Toll-Free 1-888-313-2665

Visit us on the Internet at www.arcadiapublishing.com

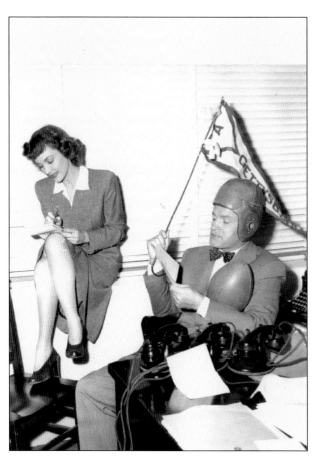

Comedian Bob Hope, in his Hollywood office, dictates a gag letter to Henry "Hen" Bream in November 1951, prior to the final game of Bream's fabled coaching career. Hope predicts success against arch-rival Franklin and Marshall College, adding that he knows Marshall "but how does this fellow Franklin keep on playing football? Shouldn't there be some question about his eligibility after all these years?" Gettysburg prevailed, 40–20, and Bream was carried off the field on the shoulders of his players. (Courtesy of Jack Bream.)

CONTENTS

ACKNOWLEDGMENTS

Few projects can match the sheer pleasure entailed in producing an illustrated history of a venerable college. While researching this work, we came across hundreds of fresh and sometimes surprising images of the people and events that have defined Gettysburg College since its founding in 1832. We laughed while viewing some of the photographs we encountered. Occasionally we cursed our inability to find others that we assumed the college would by rights house in its archives. In some cases, sleuthing enabled us to identify elusive dates or people; in others, we remain mystified.

Whatever its strengths and limitations, this book would not have been possible without the good will and assistance of many individuals. David Schuyler, the Shadek Professor of Humanities at Franklin and Marshall College, proposed that we pursue this enterprise and offered helpful responses to inquiries along the path to its completion. Charles H. Glatfelter, emeritus professor of history at Gettysburg College and author of an authoritative college history, reviewed the text with a mixture of forbearance and constructive criticism. This book is more accurate for his conscientious scrutiny.

During our many hours searching through scrapbooks, yearbooks, alumni magazines, and other materials in Musselman Library's special collections, college archivist Karen Drickamer cheerfully responded to a steady stream of requests and queries. She also provided essential assistance as the project entered its final phase. Assistant archivist Christine Ameduri, archival assistant Catherine Perry, and a flock of student assistants also responded with good results whenever aid was sought. Catherine Perry was an essential aegis in the final scanning of photographs. We are grateful also to Kim S. Breighner, computer instruction specialist, for assistance at a critical juncture in the gestation of the project.

This book would not exist without the enthusiastic backing of Gettysburg College president Katherine Haley Will and her executive assistant Jane North. A grant from the 175th anniversary committee made possible David Crumplar's work on this project in the summer of 2005 and throughout the academic year 2005–2006. Members of the anniversary committee have enthusiastically supported our work, as has Musselman Library director Robin Wagner. Both the committee and Wagner provided meaningful aid and encouragement from start to finish.

Thanks to all.

INTRODUCTION

Founded in 1832—a time of social ferment and advancing democracy—Gettysburg College is the oldest Lutheran-affiliated college in the United States. The man most responsible for its founding, Samuel Simon Schmucker (1799–1873), was something of a prodigy. Born in Hagerstown, Maryland, the son of a Lutheran pastor, Samuel was educated at the University of Pennsylvania and the Princeton Theological Seminary. As a young man his announced objectives included translating German theological work into English, founding a Lutheran theological seminary (there were none in the nation at the time he attended seminary), and establishing a college under Lutheran auspices. Schmucker accomplished all three goals by the age of 33.

The college Schmucker founded was Lutheran in its complexion, and for nearly a century Lutherans dominated its faculty and student body. Gettysburg presidents nonetheless emphasized the non-sectarian character of Pennsylvania College (its name did not formally change until 1921) and the college's liberal arts mission.

In late June 1863, with news of an approaching Confederate force led by Gen. Robert E. Lee, Pennsylvania College students abandoned their studies and volunteered for duty in the Union Army. The college's main building, Pennsylvania Hall, served as a field hospital during the battle and for several weeks thereafter wounded soldiers recuperated or died there. On November 19, 1863, Gettysburg students joined Pres. Henry L. Baugher at the new national cemetery and heard Pres. Abraham Lincoln's immortal address.

After the war the campus and student body grew fairly steadily, and by the late 1880s, the first women students were matriculating. Important new buildings, most notably Recitation Hall (1889), Brua Chapel (1890), and McKnight Hall (1898) lent grace to the campus. Collegiate culture expanded beyond the long-lived literary societies to include organized athletics, a Greek system, and student government, among numerous other extracurricular activities. Students had little difficulty finding informal ways to enjoy themselves and, when possible, discomfort the faculty and administration.

Throughout a 175 year history, alumni have made useful and in some instances important contributions in many walks of life, from theology and science to law, medicine, politics and the military. Numbered among them are a governor of Pennsylvania, the director of Lutheran World Relief, MacArthur (Genius) Award recipients, the head of the Peace Corps and UNICEF, numerous bishops, congressmen, generals, and college presidents, a Newbery Prize winner, an Oscar nominee for cinematography, the chief executive officer of the NAACP, and a recipient of the Nobel Prize in Medicine.

Well into the 20th century the student population at Gettysburg College remained below 600, although it enjoyed a growth spurt in the 1920s, under Pres. Henry W. A. Hanson. During the prosperity decade Hanson oversaw the construction of new buildings and impressive campus gardens. Buffeted by the Depression and World War II, the college did not regain its momentum until the postwar boom in higher education led to a major influx of students, most of whom were not Lutheran.

A 200-plus acre campus is today home to more than 2,500 students and nearly 200 full-time faculty. Interdisciplinary programs have prospered since their introduction in the mid-1980s. Early in the 21st century, among other initiatives, Gettysburg College established the Christian Johnson Center for Creative Teaching and the Sunderman Conservatory of Music. The college has commenced refashioning its affiliate, the Eisenhower World Affairs Institute (based on campus and in Washington, D.C.), as a significant center for the study of public policy. Its Center for Public Service has been repeatedly recognized since 1990 for innovative, high-quality programs connecting Gettysburg students to local, state, national, and international service.

Gettysburg's mission, as expressed in 1832, remains recognizable in today's larger, substantially more diverse, and outward-looking institution. By looking back at the college's founding and the changes its has experienced since 1832, we hope readers will find interesting continuities as well as contrasts between the "good old days" and today.

One

"A SALUTARY INFLUENCE"
1832–1865

Gettysburg College owes its founding to a visionary Maryland native, Samuel Simon Schmucker (1799–1873). A graduate of the University of Pennsylvania and the Princeton Theological Seminary, Schmucker felt keenly that Lutherans needed their own institutions of higher education. Other denominations had already established colleges in the Mid-Atlantic region. In the course of six years, Schmucker helped launch both a theological seminary (1826) and a college (1832) in Gettysburg, each of which has since operated continuously.

Although Pennsylvania College was Lutheran in orientation, Schmucker—partly to win local support for the venture—emphasized that the college would be "unsectarian in its instructions." Supported by prominent members of the Maryland Synod, notably Benjamin Kurtz and John G. Morris, and Adams County community leaders (of whom the most outstanding was a young legislator named Thaddeus Stevens), Schmucker made good on his goal of training liberally educated young men.

During its first decades, Pennsylvania College relocated from its original building on the corner of High and Washington Streets to a handsome campus just north of town. A Doric edifice constructed with state funds in 1837 was the first major building on the new campus, followed by a science building (Linnaean Hall) built in part with student labor in 1847, and a presidential manse, constructed in 1860. The college was soon turning out graduates who would become leaders in the church, business, law, and medicine. No one could anticipate that national events would, by 1863, identify Gettysburg indelibly with a great Civil War and—with Abraham Lincoln's two-minute address—the redefinition of American democracy.

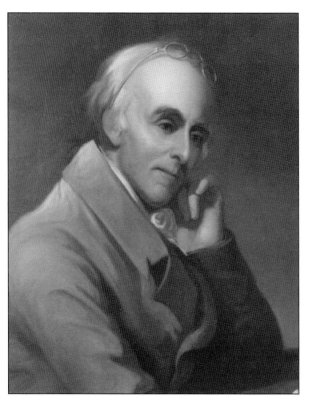

A leading physician, political activist, and educator in the early republic, Benjamin Rush (1745–1813) played a critical role in founding both Dickinson College and Franklin College (later Franklin and Marshall College), in the late 18th century. Rush's vision for a college serving Germans in Pennsylvania was finally realized in the founding of Pennsylvania College of Gettysburg. The new college—part of a wave of small colleges founded in this era—was incorporated in 1832 and granted its first baccalaureate degrees in 1834.

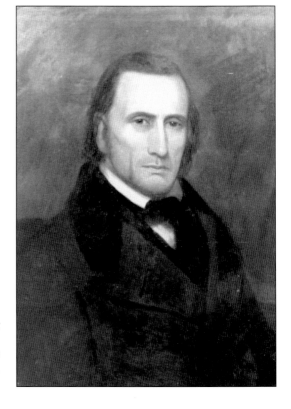

This is the college's founder, Samuel Simon Schmucker (1799–1873), in a portrait depicting him in his late 20s. An important figure in American Lutheranism, Schmucker was also an abolitionist sympathizer and a pioneer in the field of psychology. He founded both the Gettysburg Seminary and the Gettysburg Academy before launching Pennsylvania College of Gettysburg.

Shown here is page one of the minutes of the first meeting of the Pennsylvania College Board of Trustees, July 4, 1832. The minutes commenced with a listing of board members, among them J. B. McPherson of Gettysburg and college founder Samuel Simon Schmucker.

Less than two months after the board first met, the inaugural faculty at the college presented a "course of instruction" to "a number of gentlemen competent to judge of its merits" and asked for their "influence in recommending students to our institution." Although the number of graduates remained low through the Civil War era (not reaching a dozen or more graduates per year until 1839), matriculating college students never numbered fewer than 50 after 1837.

Printed in central Pennsylvania newspapers beginning in August 1832, this advertisement announces the opening of a new college with a special attraction for Pennsylvania Germans.

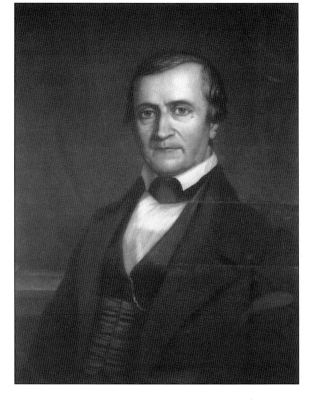

Although Samuel Simon Schmucker maintained a deep interest in the college, his primary commitment lay with the seminary on the hill. When his bid to attract Edward Robinson (a non-Lutheran clergyman from upstate New York) as the college's first president proved unavailing because of Robinson's uncertain health, seminary professor Charles P. Krauth (1797–1867) was unanimously named president. He served from 1834 to 1850.

Depicted at right is the college seal from its founding until 1921. A new Gettysburg College seal will be unveiled to mark the college's 175th anniversary in 2007.

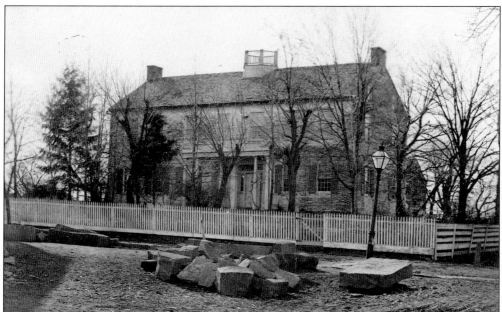

The college's original building—located on the corner of High and South Washington Streets in Gettysburg borough—was also the original home of the Gettysburg Seminary, founded in 1826, and the Gettysburg Academy. President Krauth lived in the original building as house master, a role he continued to play after a new college edifice was constructed in 1837.

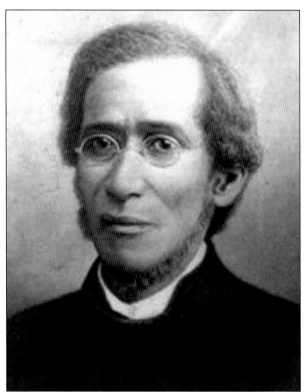

Daniel Alexander Payne (1811–1893), a free-born African American native of South Carolina, enrolled in the Gettysburg Seminary in 1835 with the encouragement of Samuel Simon Schmucker. In 1837, Payne was authorized to teach a Bible class of "colored people" in one of the rooms at Pennsylvania College. Payne eventually became a bishop of the African Methodist Episcopal Church in Philadelphia. He was founder and first president of Wilberforce University in Ohio.

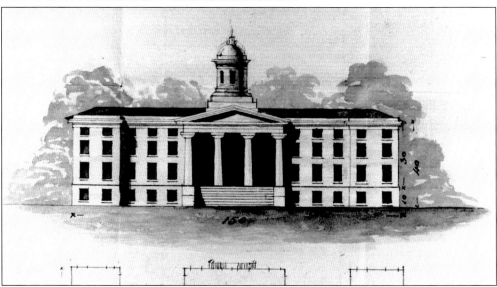

Two years after its founding, Pennsylvania College boasted several dozen students but no new building in which to instruct and house them. With the strong support of local legislator Thaddeus Stevens, college trustees and local community leaders appealed to the state legislature for aid. An $18,000 appropriation made it possible to find a site and construct a building. Above is an undated drawing that college architect John C. Trautwine submitted to the college building committee in 1835. Trautwine's design is considered "country style" Greek Revival.

Best known to history as the "scourge of the South" during the Civil War era, Thaddeus Stevens (1792–1868) was also a prominent figure in reform movements of the antebellum era, among them abolitionism and public education. A longtime trustee of Pennsylvania College, Stevens is here depicted by artist Jacob Eicholtz in a distinctly idealized portrait. Notice Pennsylvania Hall over Stevens's right shoulder.

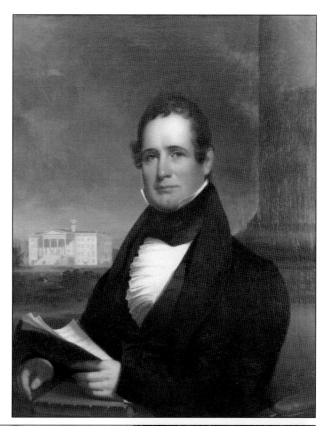

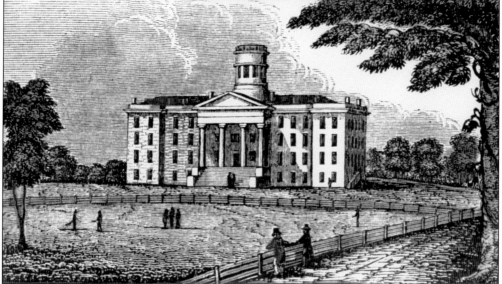

John Trautwine's original plan for the college edifice underwent a number of helpful mutations, leading to the construction in 1837 of what one observer called "a chaste specimen of the Doric order." This lithograph of what came to be known as Pennsylvania Hall is undated but probably was made in the early 1840s, in the format popularized by the well-known lithographers Barber and Howe.

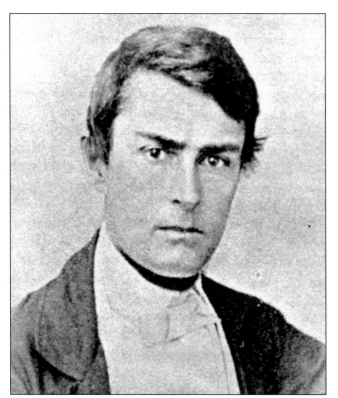

A graduate of West Point, Herman Haupt (1817–1905) was appointed instructor of civil engineering and architecture at the college at the age of 20 in 1837 and to a professorship a year later. Although Haupt remained at the college only until 1839 (serving another stint on the faculty from 1845 to 1847), he was principal architect of Linnaean Hall and later served 14 years as a member of the board of trustees. Haupt gained national renown for his engineering exploits during the Civil War.

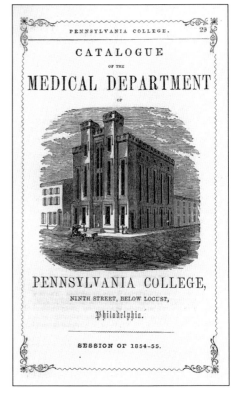

In 1839, the college trustees authorized the operation of a medical department of Pennsylvania College, based in Center City Philadelphia. For several years the department enrolled more students than did the undergraduate college. Despite its strong reputation in the medical field, the college could not financially sustain the program. It was closed down in 1861, and the building was sold in 1863. This image appeared in the 1858 college catalog.

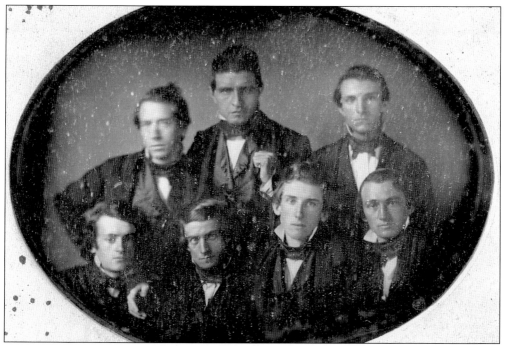

In 1851, the new photographic art of daguerreotype was increasingly popular. Members of the Gettysburg class of 1851 could not all fit into one picture, so two were taken. In the top photograph on this page, probably by William H. Caslow, David Wills is second from right in the front row. Wills became a prominent local attorney; it was he who invited Abraham Lincoln to stay at his home on the square in Gettysburg when Lincoln visited town in November 1863 to dedicate the new national cemetery.

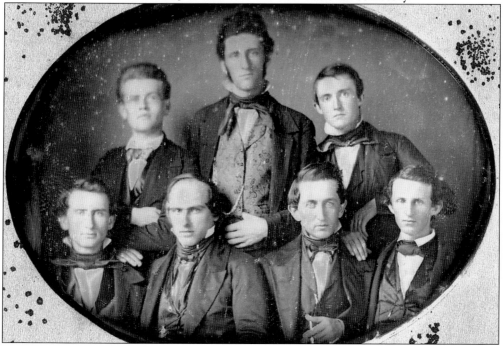

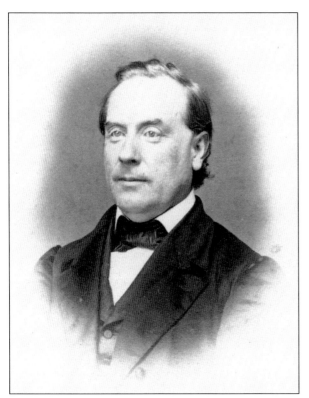

Martin Luther Stoever (1820–1870) was a well-regarded early faculty member at the college. An 1838 alumnus, Stoever returned first as a tutor (1839) and then in 1841 as principal of the preparatory department. In 1843, he was named professor of history—the first ever at the college. Seven years later, Stoever was awarded the title of professor of Latin language and literature. A prolific author, for many years Stoever also edited a popular journal of Lutheran thought, while maintaining strong contacts with a growing roster of alumni.

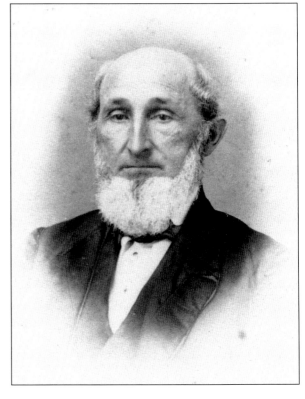

Henry L. Baugher (1804–1868) succeeded Charles P. Krauth as president of the college in 1850 and served until his death. Baugher offered the benediction on November 19, 1863, at the dedication of the Gettysburg cemetery, at which occasion Abraham Lincoln delivered his immortal address.

Raising money was a priority for trustees early on in the college's history. In 1850, partly as a result of receiving assets from the accounts of the former Franklin College, which was merging with Marshall College, Gettysburg received more than $17,000 to fund a Franklin Professorship in Ancient Languages. The holder of this first chair was Frederick A. Muhlenberg (1818–1901). A graduate of Jefferson College and the Princeton Theological Seminary, Muhlenberg served as a professor of ancient languages at Gettysburg from 1853 to 1867, when he resigned to become the first president of Muhlenberg College.

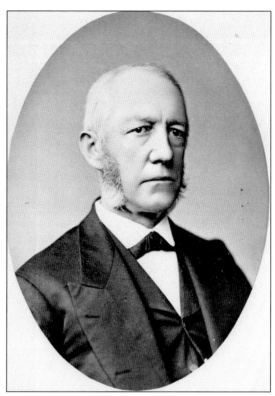

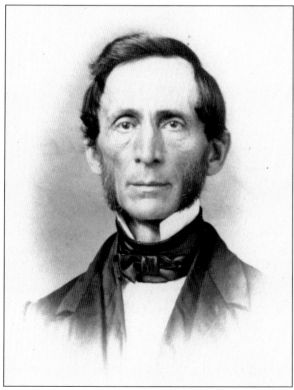

As Henry Heth's division began pounding Union forces on Seminary Ridge the 1st of July, 1863, the family of Prof. Michael Jacobs (1808–1871) retreated to home at the corner of Washington and Middle Streets. Jacobs himself made "frequent trips" to the cupola of the house, using the college telescope to observe the battle in progress. Several months later, Jacobs published the first book about the battle of Gettysburg. He followed up with several articles, including one that made the unverified claim that Robert E. Lee had used the cupola at Pennsylvania Hall as an observation post.

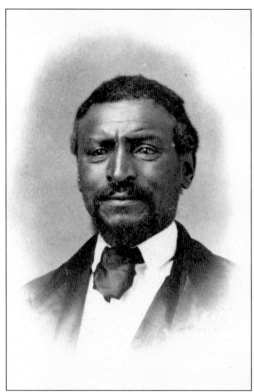

College janitor John Hopkins (1806–1868) would normally not gain attention in a history book like this. But Hopkins was an ubiquitous and popular figure on campus. He also played a role in preparing the town's African American community for the Confederate invasion in July 1863. When he died three years after the Civil War ended, Pres. Milton Valentine and two faculty members conducted services. This picture is from an 1862 album identifying Hopkins affectionately as "Vice President of the College."

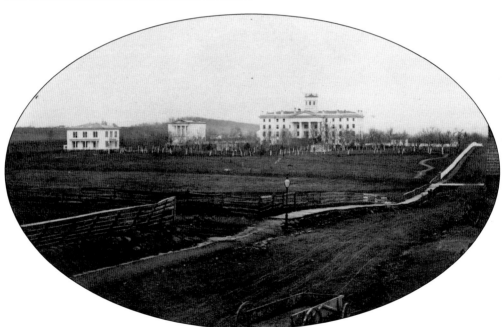

This is the first-known photograph of the college campus, taken about 1862. The road on the right edge of the picture is North Washington Street. One year after this photograph was taken, Pennsylvania College students left the campus to join Company K, Pennsylvania Volunteers, offering their service to the Union cause at a perilous time.

Two

GROWING PAINS
1865–1900

Pennsylvania College did not swiftly bounce back from the cyclone of war. The college edifice needed substantial repairs in the wake of its service as a field hospital, the expenses for which were only partly reimbursed by federal authorities. The modest stream of southerners matriculating at Pennsylvania College essentially dried up. Finances were tight and remained so throughout the 19th century. During the presidency of Harvey McKnight (1884–1904), there were battles over the degree to which Lutheran theology was to be part of the teaching curriculum. Facing fire from Greek professor H. Louis Baugher, McKnight stood firm against Baugher and others who would inject their religious values into the classroom. McKnight was backed by his board of trustees.

High points of this peripatetic era included the addition of new endowed professorships, advances in scientific education, enlargement of the campus grounds and a growing student body, including the first women students. Between 1882 and 1900, Pennsylvania College awarded 15 doctorates, one of them to a woman, Julia Painter (1897). Not least important was the construction of a half dozen new buildings, among them Stevens Hall (1867), an astronomical observatory (1874), Recitation (Glatfelter) Hall (1889), Brua Chapel (1890), and a new mens' dormitory (1898) that was later named after President McKnight. Glatfelter Hall is commonly acknowledged as the campus's architectural gem.

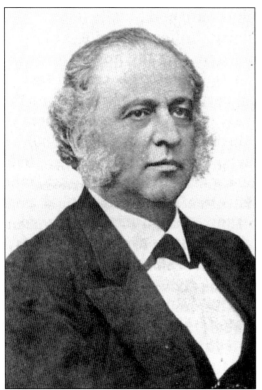

John E. Graeff '43 was one of Pennsylvania College's most generous benefactors. In 1865, Graeff, a Philadelphia coal merchant, gave $20,000 to establish a professorship in English. Subsequently he made a major gift for the construction of Recitation Hall in 1888. Graeff served as a trustee from 1864 until his death in 1898 and as the board's president from 1887 until 1898.

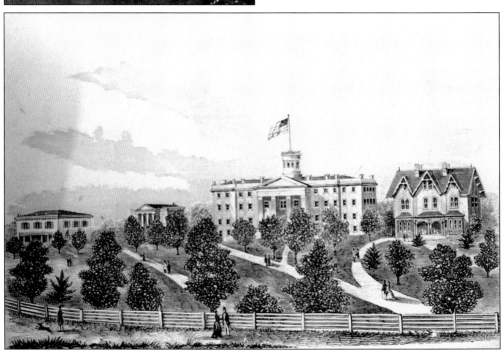

This campus scene from the Pennsylvania College catalog, 1870, shows the president's house, built in 1860, at far left, adjacent to Linnaean Hall. The Victorian-style building, just east of Pennsylvania Hall, served as a faculty residence.

22

Milton Valentine (1825–1906) served as Gettysburg College's third president. A Maryland native and member of the Pennsylvania College class of 1850, Valentine was a professor at the seminary when called to Gettysburg's presidency. During his 16-year term of service (1868–1884), Valentine oversaw construction of several new campus buildings, including Stevens Hall (1868) and an astronomical observatory (1874). As president, Valentine emphasized truth seeking and the need to adapt to changing currents in higher education.

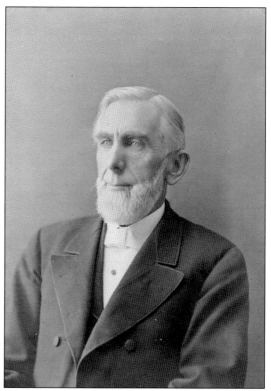

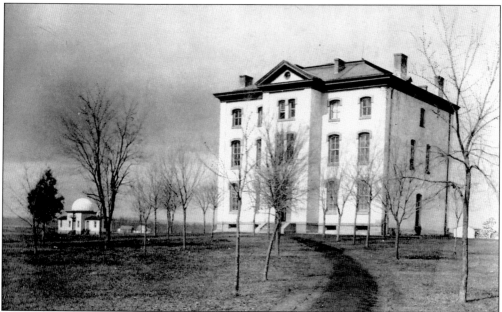

Originally designed to serve as the preparatory department for the college, Stevens Hall lacked a major donor and was finally constructed in large measure through a mortgage. It was named in honor of the "Great Commoner," Thaddeus Stevens, who played an important part in the college's early history. After the dissolution of the preparatory school in 1935 Stevens Hall was transformed into a woman's dormitory.

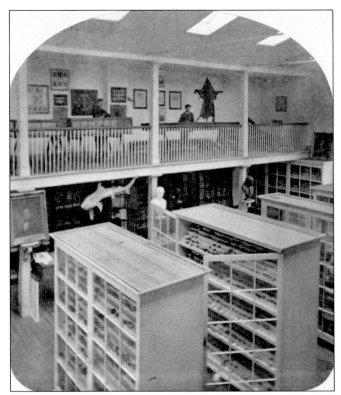

These two views of the interior of Linnaean Hall document the college's extensive collection of minerals and other scientific specimens. Designed by Prof. Herman Haupt and constructed with student labor in the 1840s, Linnaean Hall remained a campus fixture first as a science building and, beginning in 1890, as a gymnasium. Its condition deteriorated steadily and the building was demolished during World War II.

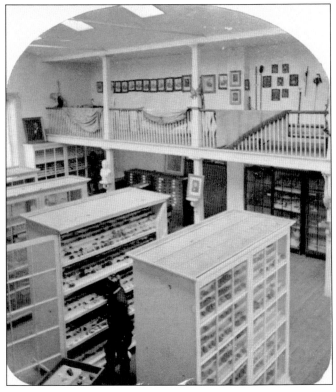

John A. Himes, Graeff Professor of English, and a nationally respected Milton specialist, taught at Pennsylvania College from 1873 until 1914. During his long tenure at Gettysburg, Himes also taught physics and history. Himes's daughter Margaret was one of the first two women graduates of the college.

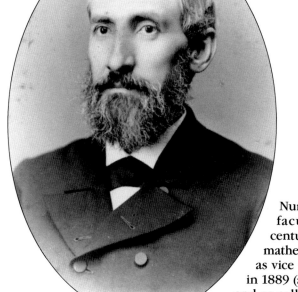

Numbered among the more influential faculty members in the late 19th century, Luther Croll '55 was professor of mathematics (1866–1889). Croll also served as vice president from 1873 until his death in 1889 (a precursor to the college deanship), and as college librarian. The library, however, was open to students only one day a week.

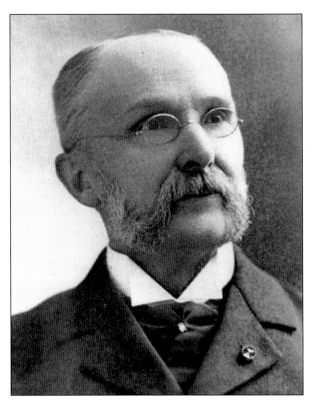

Harvey McKnight (1843–1914) was barely 40 years of age when called to the Pennsylvania College presidency. He supported a "soundly Christian" education at Gettysburg and was committed to retaining the core curriculum of Greek, Latin, and mathematics. McKnight was the first president who spent much time soliciting funds from a range of constituencies, particularly for a building that would be a "wider place for a greater work" on campus.

One of the most influential and respected Pennsylvania College professor in the half century between Reconstruction and the "New Era" of the 1920s was professor of chemistry Edward S. "Old Breidey" Breidenbaugh '68 (1874–1924). Although he never completed his doctorate at Yale, Breidenbaugh was ultimately awarded an honorary doctorate by his alma mater. Breidenbaugh Hall was named after him shortly after his retirement from active service on the faculty. This photograph of Breidenbaugh was taken in the mid-1880s.

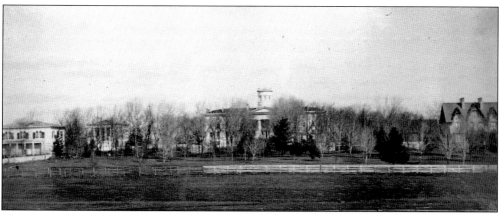

This panoramic view of Pennsylvania College portrays the campus as it looked when the institution marked its semi-centennial in 1882. It was originally published in the *Pennsylvania College Book* by editor E. S. Breidenbaugh in 1882, marking an important anniversary.

The *Pennsylvania College Monthly* made its debut in 1877 and, for the next sixteen years, under the editorship of Prof. Philip M. Bikle, provided news and views about the college and higher education generally. As Pennsylvania College grew, a movement to establish student publications gained momentum. The monthly found itself challenged and then superseded, by the *Mercury* (established in 1893) and the *Gettysburgian* (founded 1897), respectively. The *Mercury* morphed into a literary magazine by 1898, while the *Gettysburgian* has remained the dominant student newspaper.

Pennsylvania College Monthly,

PUBLISHED THE FIRST OF EACH MONTH DURING TERM TIME.

P. M. BIKLE, Editor.

ASSOCIATE EDITORS: W. C. STŒVER, - - - *Alumni Association.*
CHARLES W. HEISLER, - *Phrenakosmian Society.*
LINDLEY N. FLECK, - - *Philomathœan Society.*

TERMS: One Dollar and twenty-five cents per annum in advance.

EDITORIAL NOTES.

No More Games Abroad.—After our Foot-ball eleven received a challenge from the Dickinson club to play a return game, a request for permission to go to Carlisle for this purpose was presented to the Faculty but declined. The next day the request was renewed in a petition signed by most of the students, in which special stress was put upon what might appear a lack of courtesy on the part of our club to the Dickinson club, in case the challenge to play a return game was not accepted. The following action was then taken by the Faculty, which, by special resolution, was given to the Monthly for publication:

Resolved, That the action of the Faculty in declining to allow the Foot-ball club to go to Carlisle to play with the Dickinson College club was in accordance with a fixed principle that such excursions are not in accordance with the objects of College communities and are subversive of the best discipline.

Resolved, however, in view of the position of our students in relation to the Dickinson students, and to relieve them from any charge of want of courtesy, that we consent to the petition.

Resolved, That we now enact a standing rule, that, hereafter, no proposition looking to the making or accepting a challenge to play any game or engage in any athletic exercises, away from the College grounds, be entertained at all by the Faculty.

Pennsylvania State College.—There is an institution somewhere in Centre county, Pa., whose act of incorporation dates

Grade of Scholarship.

PENNSYLVANIA COLLEGE.

Gettysburg, Pa., *Mrch 26* 1885

DEAR SIR:

Annexed is the Official Report of

Franklin Menges

of the *Junior* Class for the Session ending *Mch 26* 1885

The numbers in this Report are on a scale in which the maximum is 100, and 50 is the lowest grade that will enable the Student to remain in the Class. Unexcused absences from recitation are counted as zero upon the grades.

The attention of Parents and Guardians is specially called to the fact that absences from recitation, whether at the opening of Term or at other times, are not excused except for sickness or imperative necessity.

Students are graded in Deportment: the highest grade being 100, from which reductions are made for violations of the Regulations, misdemeanors, and unexcused absences from College duties.

The next session will begin *April 7th* 1885

H. W. McKnight President.

IN MATHEMATICS,	
LATIN,	
GREEK,	
FRENCH,	
GERMAN,	
HISTORY,	
ENGLISH,	
ANGLO-SAXON,	
RHETORIC,	
COMPOSITION,	
DECLAMATION,	
LOGIC,	
POLITICAL SCIENCE,	
NATURAL PHILOSOPHY,	98
CHEMISTRY, *An. chmsty*	97
	100
ASTRONOMY,	
MINERALOGY,	100
GEOLOGY,	
ZOOLOGY,	
BOTANY,	
MENTAL SCIENCE,	
MORAL SCIENCE,	
NATURAL THEOLOGY,	
CHRISTIAN EVIDENCES,	
BIBLICAL RECITATION,	
DEPORTMENT,	100

	Excused.	Unexcused.
ABSENT FROM PRAYERS,	11	
" " CHURCH,		
" " RECITATION,	3	
" " BUILDING,		

GENERAL REMARKS:

A grade report for 1885 reflects the range of subjects taught at Pennsylvania College and one student's performance.

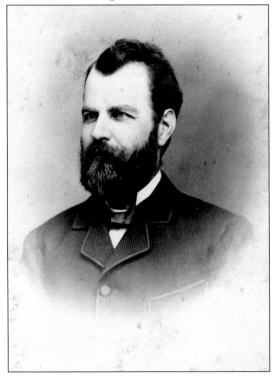

Philip Melanchthon Bikle '66 served for more than a half century (1874–1925) as a professor of physics, astronomy, and Latin. Bikle edited the *Pennsylvania College Monthly* for 16 years (1877–1893) and later served two decades as dean of the college. After the demolition of the college faculty house in 1914, the Bikle family moved into a handsome brick home on Lincoln Avenue.

Clubs proliferated as the student body grew in the late 19th century. Some were political, among them a Gettysburg College Prohibition Club, which sought to end the traffic of liquor in the United States. Others were social, including fanciful organizations like the Royal Society and the Knights of the Golden Fleece, memorialized in various yearbooks.

THE GETTYSBURG COLLEGE PROHIBITION CLUB.

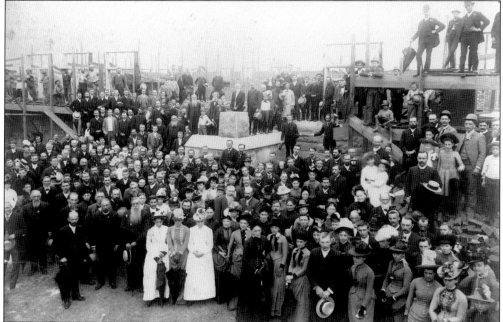

No building on campus has more claim to architectural distinction than architect John A. Dempwolf's Recitation Hall, which was dedicated in September 1889, and in 1912 renamed Glatfelter Hall in honor of a key donor. This photograph was taken at the laying of the building's cornerstone on June 27, 1888.

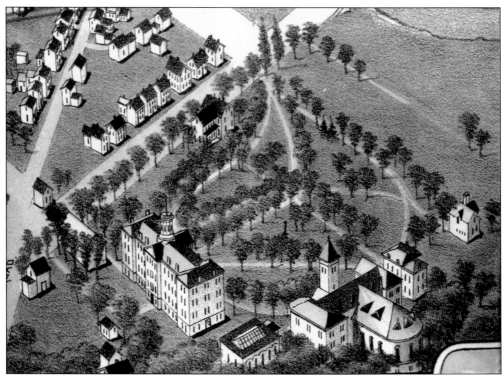

This drawing by T. M. Fowler and A. E. Downs depicts Glatfelter Hall as originally designed, with the west wing originally intended as the college chapel. A major gift by the Brua family made it possible to hire architect Dempwolf to design a separate structure for the college's chapel. Consequently the west wing of Glatfelter Hall was never built.

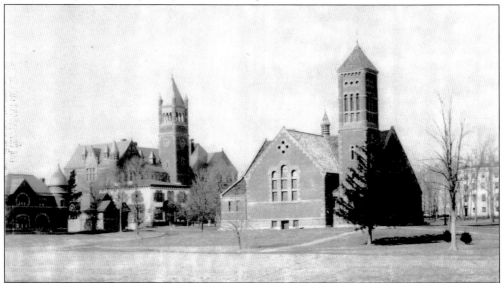

This photograph from the early 1890s captures an important slice of the campus looking north from town. At far left, the original Phi Gamma Delta house, immediately adjacent to the president's house. Glatfelter Hall and Brua Chapel are visible in the center right. In the right background is Pennsylvania Hall.

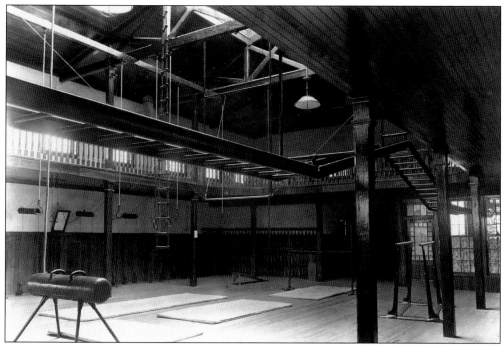

Once Recitation Hall was completed, the college needed to rethink the use of space on campus. Professor Breidenbaugh proposed that the functions of Linnaean Hall and McCreary Gymnasium be reversed. In 1889, the board of trustees endorsed this concept and contractors were hired to complete the task. Above is a view of Linnaean Hall in the 1890s when its primary use was for gymnastics. Below is McCreary Laboratory. McCreary was demolished when a new chemistry building, Breidenbaugh Hall, was constructed in 1927.

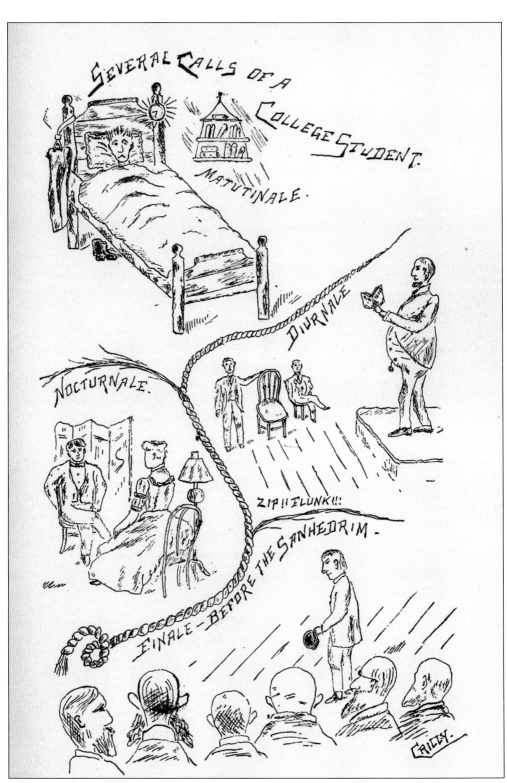

A student artist rendered the cycles of daily life at Gettysburg for the 1894 *Spectrum*.

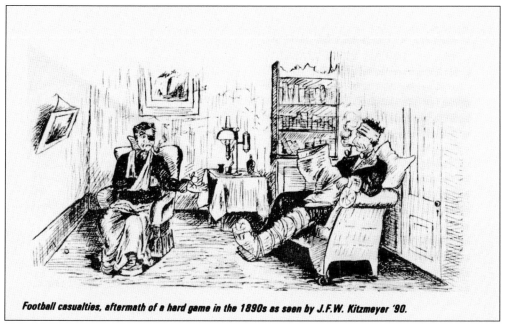

Football casualties, aftermath of a hard game in the 1890s as seen by J.F.W. Kitzmeyer '90.

For a satirical view of football suggesting its dangers, this line drawing by J. F. W. Kitzmayer '90 is evocative.

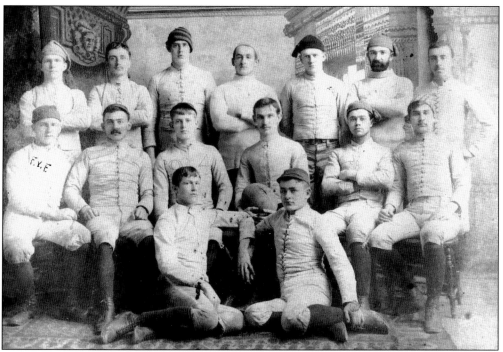

Intercollegiate sports gained popularity in the late 19th century, with the organization of teams in baseball, football, basketball, and track and field. Football enjoyed its debut as a club sport in 1879, triumphing 11–6 over the Dickinson College varsity squad. However, Gettysburg College fielded no varsity football team until 1890. Above, the 1891 football squad poses for the 1892 *Spectrum*.

Pennsylvania College took on a different complexion in the last years of the 19th century as women began to matriculate, albeit as day students. Beulah Tipton is portrayed above, far right with her family, including her father W. H. Tipton, second from left, and her mother Elizabeth, second from right. Beulah entered Gettysburg in 1888. Illness cut short her studies and she did not graduate.

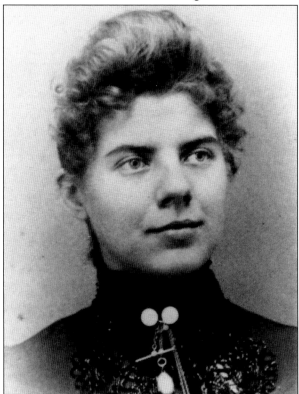

Margaret Himes and Cora Hartman were the first female graduates of Gettysburg College. Joining 60 first-year men in the fall of 1890, Himes (daughter of Prof. John A. Himes) and Hartman (who studied seven languages at Gettysburg) subsequently participated in various colleges activities. Hartman, at left, married Harvey Berkey '92 and lived in Gettysburg from 1924 until her death in 1969, at which time she was the college's oldest living graduate. Like Hartman, Himes married a classmate who made a career as a pastor. Margaret Himes Seebach served for many years as editor of *Lutheran Woman's Work*. By 1904, a total of 76 women had matriculated at Gettysburg, but only 17 of them earned degrees.

Until the construction of Brua Hall in 1889, Christ Lutheran Church on Chambersburg Street served as the religious home of Pennsylvania College students and faculty. This photograph of what was widely known as the College Lutheran Church was taken by local photographer W. H. Tipton in the 1890s. (Courtesy of the Adams County Historical Society.)

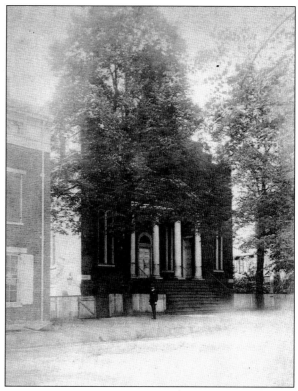

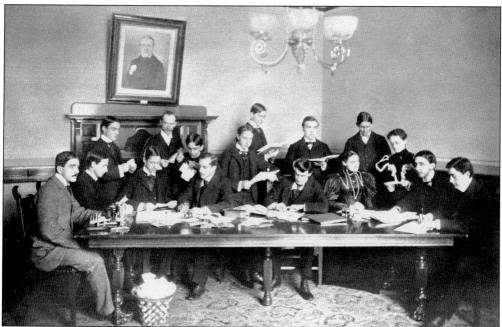

Judging by the picture above, working on the college yearbook was a serious and a popular task. This photograph of *Spectrum* staff editors for 1898 was taken during the 1896–1897 academic year. Notice two coeds, Naomi Myers and Effie Hess, both members of the class of 1898.

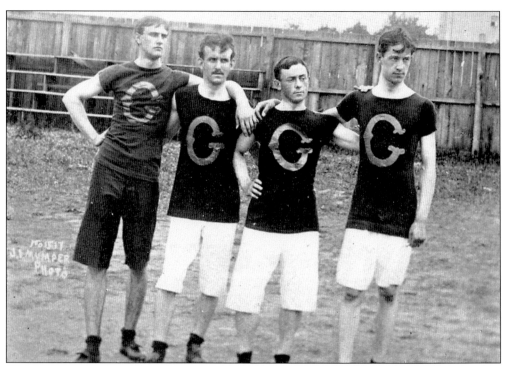

A college photographer captured the Silver Cup winners at the 1897 Penn Relays. Left to right are Harvey Grazier '98, Charles Erb '97, William Ney '02, and Charles Fite '98. The men are posed inside the fencing of Nixon Field.

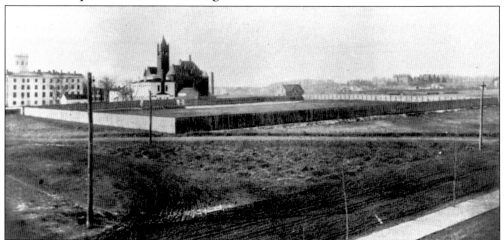

By the final decade of the 19th century, athletics at Gettysburg had achieved enough momentum that a modern field of play became a priority. In 1891, the faculty granted students a plot of land west and north of the new Recitation Building, charging them to raise any funds necessary for the facility. A national depression hindered these efforts. Ultimately a new location was suggested just north of Pennsylvania Hall, and work commenced, thanks to a timely loan of $1,000 by the trustees. Named in honor of mathematics professor Henry B. Nixon '88, Nixon Field opened for intramural competition in 1895. The first intercollegiate play on Nixon Field—a baseball game against Washington and Jefferson College—occurred in April 1896.

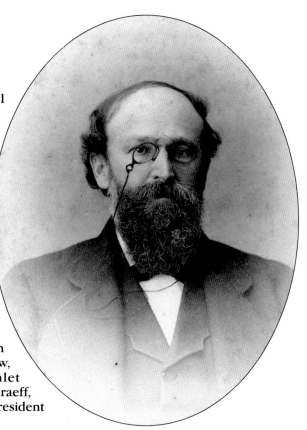

As president from 1884 until 1904, Harvey McKnight oversaw the construction of important campus buildings—notably Recitation Hall, Brua Chapel, and a residence hall that would later be named for him. But these were also vexing years. McKnight faced serious challenges, among them the depression of 1893–1897, which strained college finances, and bitter disputes over Gettysburg's brand of Lutheranism, which frayed friendships and led to the dismissal of combative Prof. H. Louis Baugher (right), who injected his conservative Lutheran convictions into his courses. Below, the cover of an 1892 pamphlet drafted by board chair John E. Graeff, President McKnight, and former president Milton E. Valentine.

THE LUTHERAN STATUS

OF

PENNSYLVANIA COLLEGE.

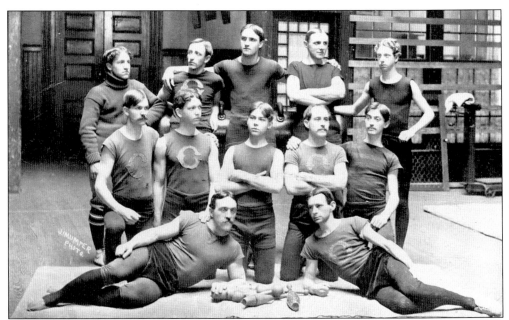

The Sons of Hercules, an intramural gymnastics group, were photographed in 1900 in Linnaean Hall, which did double duty as a basketball arena.

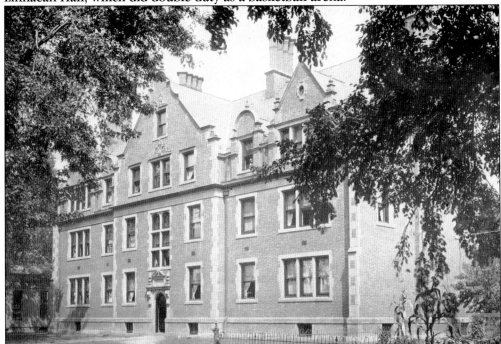

"The erection of this dormitory has proved very advantageous to the College," wrote President McKnight of the new South College facility, as it opened in January 1898. Enhanced by Indiana brownstone trim, the brick building housed 50 students, some in double rooms, and others in singles. McKnight told board members the building was attracting students who might otherwise have attended Yale. Named for McKnight in 1916, it today houses the departments of Spanish, German, French, and Italian.

Three

A "GREATER GETTYSBURG"
1900–1923

With the battles over the place of religion in the classroom behind it, Pennsylvania College was able to move forward on several fronts. A new, young president, Samuel Hefelbower (1904–1910) emphasized the importance of strong academics and put rhetoric into practice by hiring teachers with doctorates to staff the college's departments. It was under Hefelbower that in February 1909 Pennsylvania College of Gettysburg celebrated the centenary of the births of both Abraham Lincoln and Charles Darwin.

A further sign of academic seriousness was the hiring in 1910 of Yale University mathematics professor W. A. Granville as the college's president. A widely respected mathematician, Granville gave the college an intellectual boost. His membership on the Rhodes Scholarship selection committee provided a prestige lift for little Gettysburg. It is probably no accident that two graduates—Spurgeon Keeney '14 and Ordean Rockey '16—earned the coveted fellowships during this era. It was under Granville, moreover, that the college bid successfully for a chapter of the academic honorary Phi Beta Kappa.

Granville's Gettysburg was also a place of high jinks and, to some extent, menace. The sophomore class zealously exerted its prerogative to terrorize first year students, sometimes to the point of physical violence. The Sophomore Band, or Woozies, made life miserable for freshmen until customs ended after the traditional Tiber tug-of-war.

During the Granville years, Gettysburg struggled to expand its physical plant. Repeated capital campaigns pointing towards a "greater Gettysburg" yielded disappointing results. It would take a concerted effort by the newly established Women's League to make a student Christian center (Weidensall Hall) a reality in 1922.

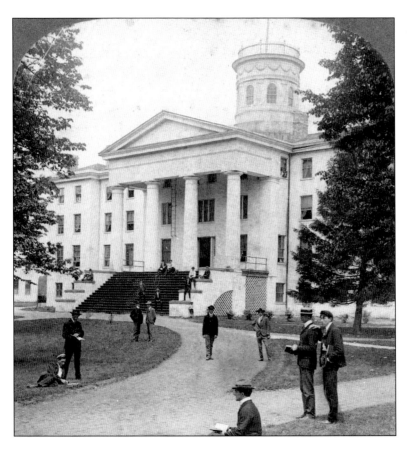

A northwest view of Pennsylvania Hall, 1903, shows the college's most venerable building just prior to the advent of the automobile age.

'01. THE JUNIOR CLASS.

MOTTO—"Ne tentes, aut perfice."

COLORS—Turquoise and Black.

Officers.

A Pennsylvania College student artist in the early 1900s depicts a classmate working, evidently without stress, on a psychology assignment.

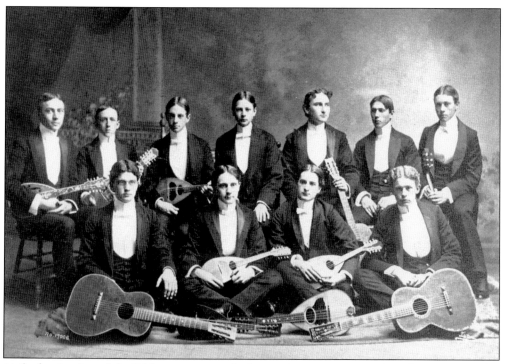

At the beginning of the 20th century, musical organizations were among the most popular student groups on the Gettysburg campus. Above is the Mandolin Club of 1904.

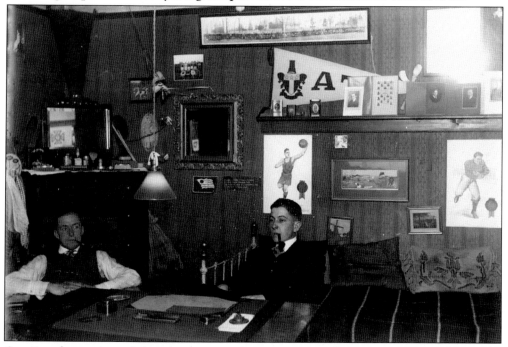

Creative decoration of dormitory rooms is not a recent phenomenon, as evidenced by this photograph of two denizens of Pennsylvania Hall around 1905. Notice the ATO pennant and class picture in the top center of this image.

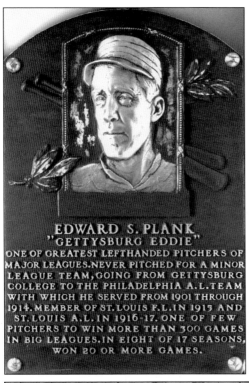

EDWARD S. PLANK,
"GETTYSBURG EDDIE"
ONE OF GREATEST LEFTHANDED PITCHERS OF
MAJOR LEAGUES. NEVER PITCHED FOR A MINOR
LEAGUE TEAM, GOING FROM GETTYSBURG
COLLEGE TO THE PHILADELPHIA A.L. TEAM
WITH WHICH HE SERVED FROM 1901 THROUGH
1914. MEMBER OF ST. LOUIS F.L. IN 1915 AND
ST. LOUIS A.L. IN 1916-17. ONE OF FEW
PITCHERS TO WIN MORE THAN 300 GAMES
IN BIG LEAGUES. IN EIGHT OF 17 SEASONS,
WON 20 OR MORE GAMES.

Edward S. "Gettysburg Eddie" Plank's Hall of Fame plaque took note of his remarkable pitching career, most of it playing for Connie Mack's Philadelphia Athletics. A Gettysburg native, Plank enrolled in the preparatory department in his mid-20s in 1899 and joined the college baseball team, where he was a standout on the mound for two seasons before signing a major-league contract.

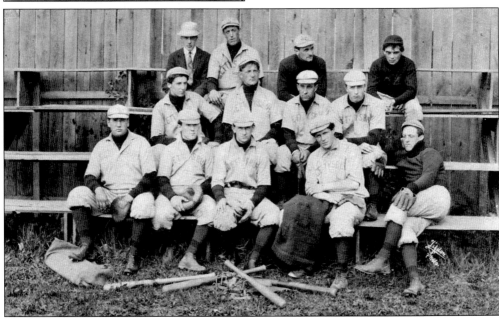

By the beginning of the 1900s, baseball at Pennsylvania College already had a two-decade history and was increasing in popularity. Eddie Plank, pictured here second from left in the third row, anchored strong Gettysburg squads in 1900 and 1901. After retiring from the major leagues, Plank returned to Gettysburg, where he operated an automobile dealership, and scouted talent in Central Pennsylvania for Connie Mack. He also assisted his brother Ira in coaching the Gettysburg baseball team. Plank died at age of 50 in 1926.

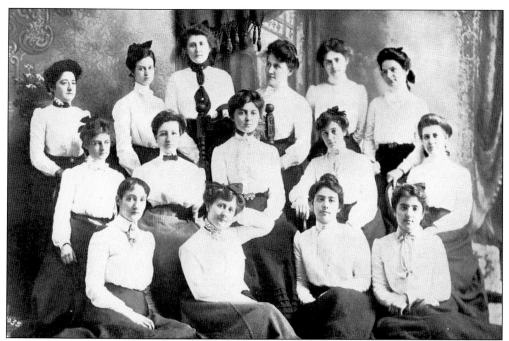

Gettysburg coeds added a new, and for most Gettysburg students and faculty, welcome dimension to college life. All of the women depicted above, around 1902, were day students, as the college chose not to provide lodgings for women.

Students are seen here in Prof. George D. Stahley's anatomy class, 1912. Early in the 20th century Pennsylvania College launched a substantial portion of its graduates to careers in the ministry. However, as had long been the case, teaching, law, business, and medicine were also popular goals for the college's students. These students were pointing towards medical school.

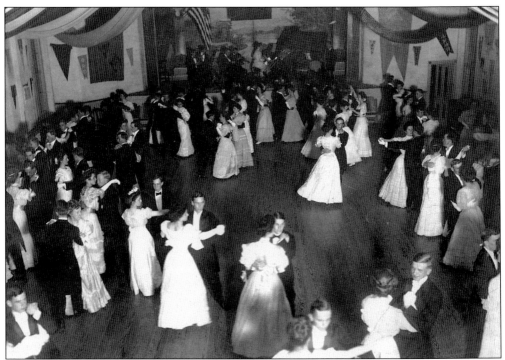

Among the most popular events of any academic year were formal dances, which were commonly held to mark Halloween, Christmas, Washington's Birthday, and Spring Dawn. Also popular was the Pan-Hellenic dance held in Recitation Hall in one of the literary societies' chambers. This photograph originally appeared in the 1909 *Spectrum*.

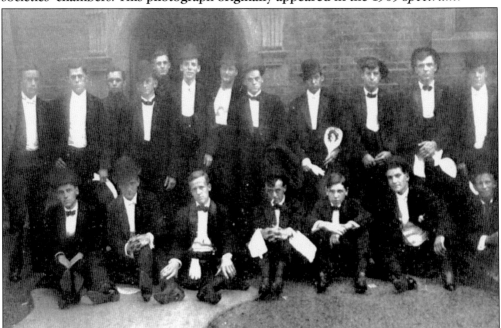

Fraternity men pose—some the worse for the wear—the morning after the Pan-Hellenic dance around 1906.

Paul "Polly" Sieber (1886–1975), captain of the
1906 football squad, is pictured here. Sieber earned
many honors as a halfback and drop-kick specialist.
After Gettysburg, he earned a doctor of medicine
degree at Johns Hopkins University and went on
to a distinguished career as a surgeon in western
Pennsylvania. He was a consistently generous
benefactor to Gettysburg's sports programs and
made a naming gift to a college infirmary building
constructed in 1960.

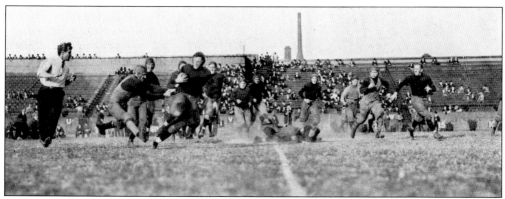

This is a scene from the Penn game in October 1908. Football was the preeminent
intercollegiate sport during the first decades of the 20th century. Gettysburg played a
varied schedule against schools smaller (Juniata College and Ursinus College) and larger
(University of Pennsylvania and Pennsylvania State University), as well as natural rivals
Franklin and Marshall College and Dickinson College.

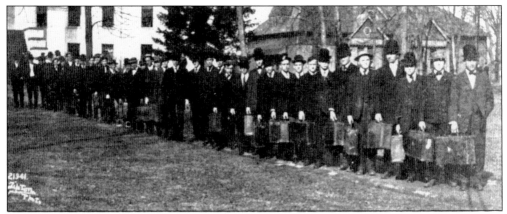

One of the most powerful traditions at Gettysburg College was the rivalry between the first and second year classes, with upper class students determined to keep the freshmen in line. Pranks, fights, and serious hazing were all part of life for freshmen men during the first decades of the 20th century. In 1907, the sophomores went a step too far in hazing the freshmen and destroying college property. Some four dozen students faced expulsion. Once they admitted their guilt and promised to reform, the perpetrators were permitted to return to the campus within a week's time, and the college went back to its regular business.

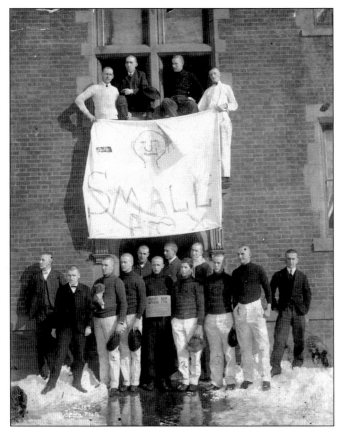

Periodic epidemics felled many students with the flu—or worse. On one occasion a smallpox epidemic forced students into quarantine. Notice the shaved heads of those pictured at left. Students did not seem to mind their status, as evidenced in this picture of "the quarantine squad," taken in February 1906.

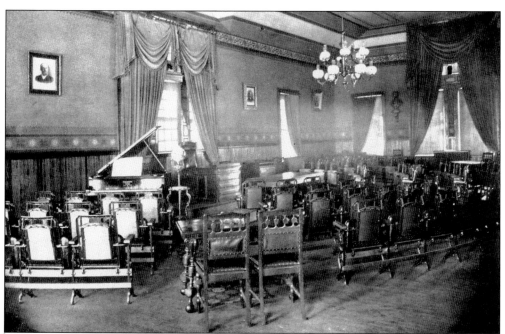

The Philomathaean and Phrenakosmian literary societies, founded early in the college's history to encourage intellectual pursuits outside the classroom, more than accomplished their founders' objectives. At the beginning of the 20th century the societies occupied some of the best real estate on campus—the third and fourth floors of Glatfelter Hall. However, the percentage of students participating in their activities steadily declined. In 1903–1904 every Gettysburg student belonged to one of the societies, but (following a national trend) this level of engagement noticeably diminished in subsequent years. By 1920, the societies were largely moribund. They formally dissolved in 1924. Above is Phrena's meeting space around 1910. Below is Philo Hall.

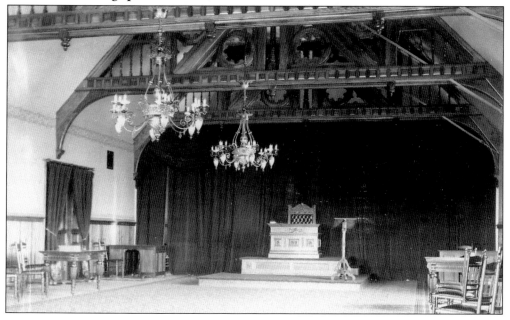

In 1910, Pennsylvania College inaugurated its seventh president and first lay leader, Yale University mathematics professor William A. Granville. Granville's presidency was event-filled and constructive—notably in the establishment of a strong new curriculum, an engineering program and success in securing a Phi Beta Kappa chapter. But the president never raised enough cash to realize his hopes for a greater Gettysburg. With busted budgets during World War I, academic standards flagging, fund-raising stymieing, and student hazing again accelerating, Granville was vulnerable to critics. In 1923 the trustees nudged him out of office.

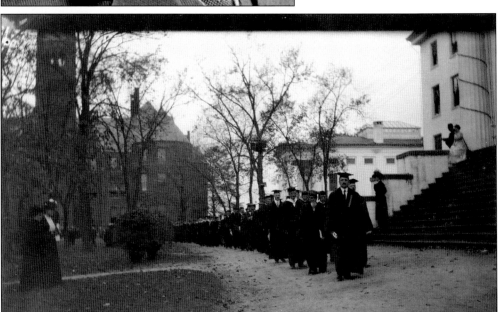

This is the parade of faculty at the inauguration ceremony for President Granville in October 1910—the first such ceremony for any Gettysburg president. As part of the festivities during the week, Pennsylvania Hall was decorated with electric lights, and Japanese lanterns were arranged throughout the campus. According to a student reporter, "never were more alumni and visitors present" at any college event.

This is a student caricature of German professor Karl Grimm, from the 1917 *Spectrum*. During his service to the college (1906–1940), Grimm managed the library along with his teaching duties, until the appointment of a full-time librarian, John Knickerbocker, in 1929.

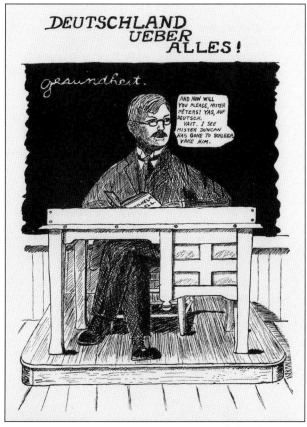

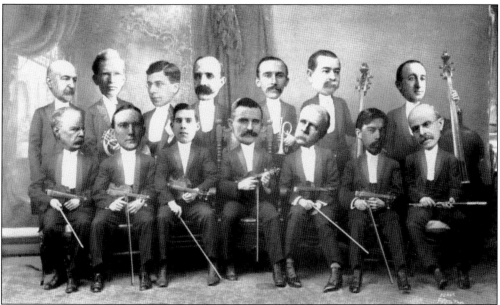

Students have always found ways of creatively depicting the college faculty. In the second decade of the 20th century, Pennsylvania College professors were portrayed as part of a "philharmonic orchestra."

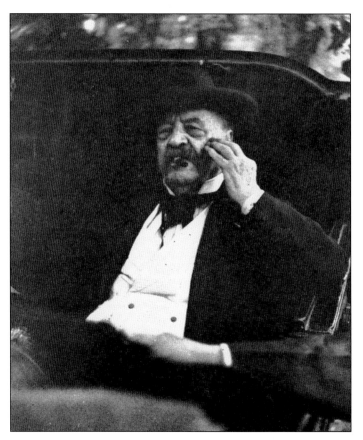

One of the special opportunities afforded students for many generations was the chance to hear firsthand stories of the Battle of Gettysburg. Few participants in the battle had a better story to tell than Gen. Daniel Sickles, who lost a leg on the Wheatfield on July 2, 1863. Sickles visited campus in September 1910 and delivered impromptu remarks to students while seated in a carriage in front of Old Dorm—a speech defending, in due course, his controversial actions on the battlefield.

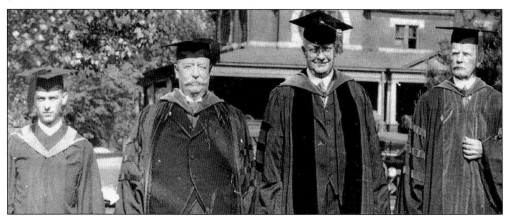

Among dignitaries to visit campus during President Granville's tenure was former Pres. William Howard Taft, shown here second from left flanked by a student on the far left and Granville second from right, with professor of biology and hygiene, Dr. George D. Stahley, standing on the far right. A campus legend, never confirmed, holds that the hefty ex-president was temporarily trapped in the bathtub in President Granville's house.

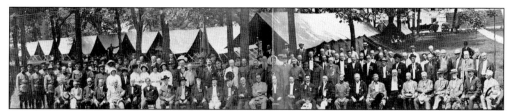

One of the major events of the Granville years was the celebration, both on the battlefield and the campus, of the 50th anniversary of the Battle of Gettysburg. Distinguished participants included Pres. Woodrow Wilson and Vice Pres. Thomas Marshall, congressional leaders, and surviving Civil War veterans. Among those pictured in this panoramic photograph, taken on the south side of Pennsylvania Hall, were seven state governors. President Granville is pictured on the far left, seated in the front row. Note the tent city temporarily established for the returning veterans.

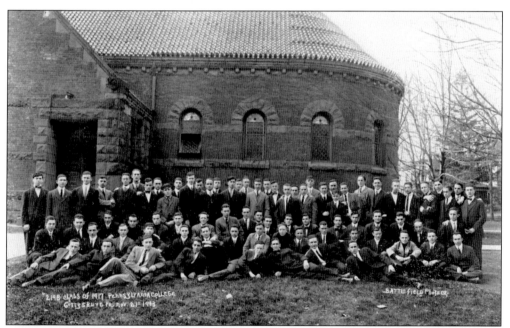

The class of 1917, was 99 members strong. The class poses, during its freshman year, for this formal portrait in front of Brua Chapel. Although spirited, the class may have set a standard for ineptitude. During its probationary months under "custons," the class lost its tug-of-war with the sophomores, lost a formal debate with upper class foes, and, in a football contest against the sophomores, was crushed 55–0. In a yearbook entry, a class correspondent noted with some pride that one member of the class, Alex Ringler, salvaged some honor by successfully capturing a greased pig at halftime during a football contest with Mount St. Mary's College.

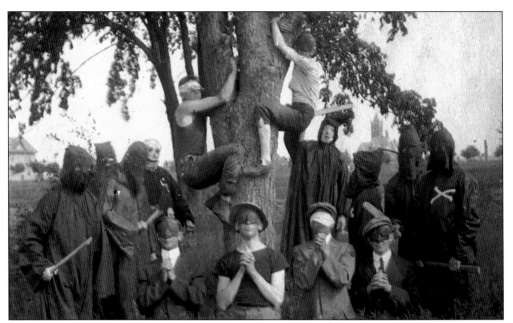

During the first decade of the 20th century, no aspect of student life at Gettysburg was more mysterious or threatening than the operations of a secret organization, Sigma Beta, known for more than a decade as the Sophomore Band. It later morphed into an equally forbidding organization, the Woozies. In either case, its mission was straightforward: initiate and, as needed, punish freshmen, often using physical force.

Beware!
Damn Freshmen, Heed

Dr. Granville has protected you far too long. Watch your step! Ye fat-headed, yellow-bellied freshies.

Art is used in wielding paddles; we are post-graduates. As--pects have been blackened. Yours will be!

Members of the Sophomore Band would frequently appear at the doors of dormitory rooms, dressed in KKK-style garb (albeit black, rather than white, robes), to seize unruly freshmen and paddle them. Repeated faculty objections did not long stymie the band. Not until 1923, with the establishment of the more public Tribunal, were the night visits to dormitory rooms ended. Above is a portion of a handbill distributed by the Woozies around 1920.

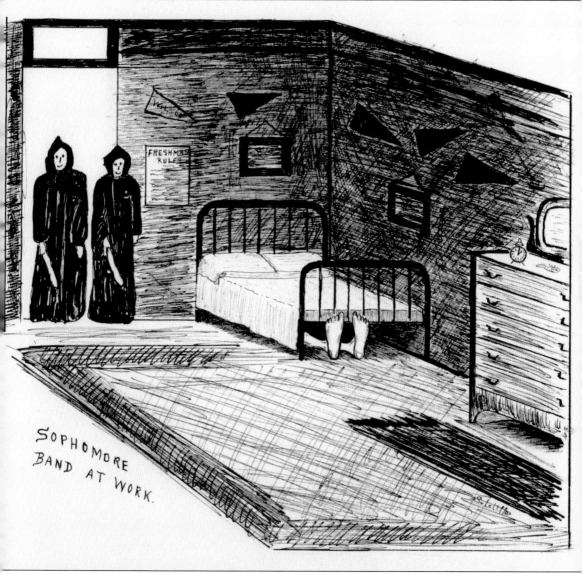

A student caricature finds mordant humor in the work of the Sophomore Band. This drawing can be found among the papers of Frank Kramer '14, a longtime chair of the Department of Education and donor of a substantial portion of the college's impressive Asian Art collection.

The student council deliberates in this photograph from 1910.

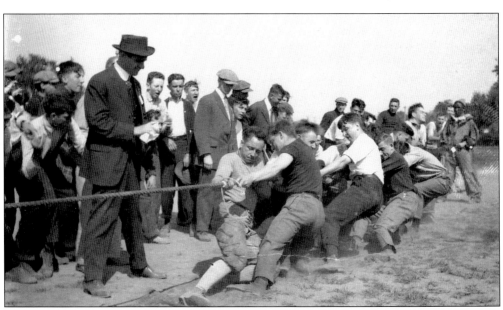
Among the more healthy competitions between first and second year students was the annual tug-of-war over the Tiber. This photograph depicts a contest that meant more to the freshmen than the sophomores. A victory for the first year students signaled the end of customs and their full acceptance into the student community.

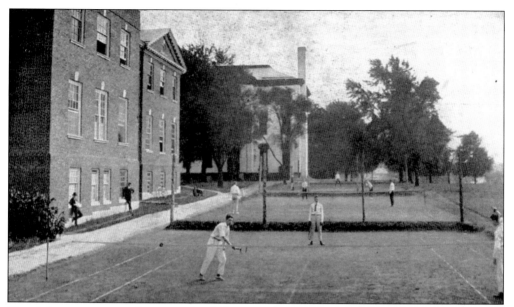

Tennis became a popular sport, both for casual recreation and competition, early in the 20th century. These courts were completed shortly after the construction of the new preparatory building (now Huber Hall) in 1916, to which they are adjacent.

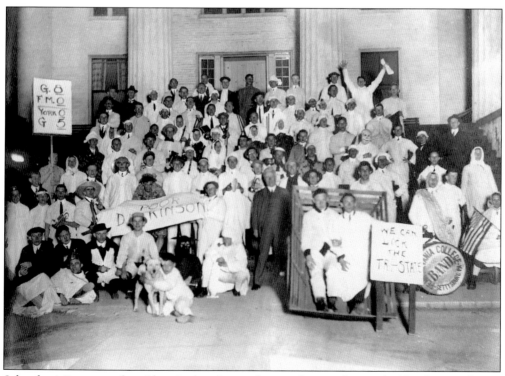

School spirit was amply evident in the picture above, taken on the north side of Pennsylvania Hall around 1913, before a big game with arch-rival Dickinson College.

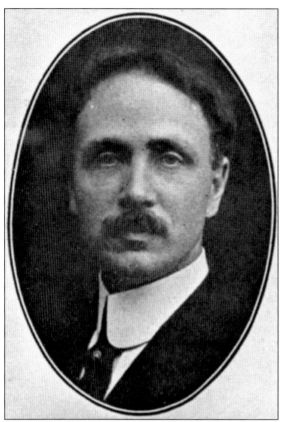

Shortly after taking office, President Granville announced that Pennsylvania College would establish an engineering program. He was able to lure to Gettysburg a colleague from Yale, Richard Shelton Kirby, pictured here, and gradually built the program to respectability. Engineering studies at Gettysburg advanced during World War I and lasted for more than two decades; but lack of adequate funding doomed the program and it was discontinued in 1940, just as the field was gaining a new impetus with the onset of World War II.

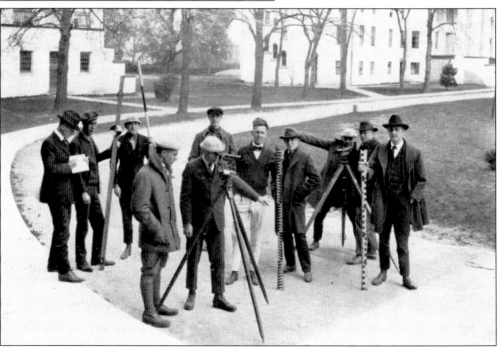

Engineering students are shown at work on campus in the 1922 *Spectrum*.

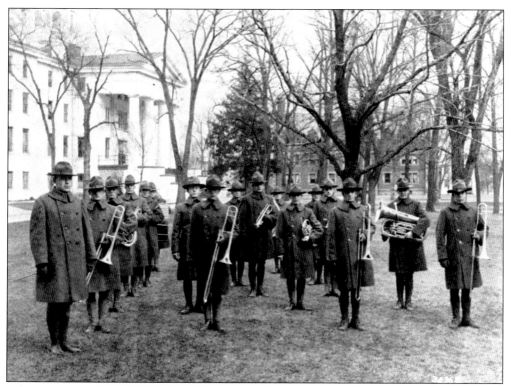

When Congress declared war in April 1917, Gettysburg was the nation's first college to apply for a Reserved Officer Training Program (ROTC). Spurred by an act of Congress, the Students' Army Training Corps (SATC) replaced ROTC in August 1918 for the duration of the war. The college's military band, pictured here, was part of SATC. It was directed by F. William Sunderman '19, pictured at far left.

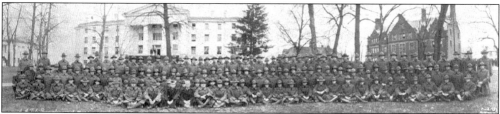

During the final months the United States was engaged in the Great War in Europe, many Gettysburg students did their part by volunteering for Roster Company A of the SATC. All the same, perhaps 15 percent of the student body left campus to join a branch of the armed forces, and the college budget felt an immediate pinch.

In 1908, Mary G. Stuckenberg, pictured on left, conceived the idea of organizing Lutheran women in the interests of Gettysburg College along lines of support for foreign missions. Stuckenberg's idea jelled and chapters were established in half a dozen Pennsylvania communities, leading in 1911 to the formation of the Woman's General League of Pennsylvania College. By the league's golden anniversary, it boasted 20 sub-leagues with over 6,000 members. Among the league's many projects was its essential contribution to the construction of a YMCA building, Weidensall Hall, in 1922.

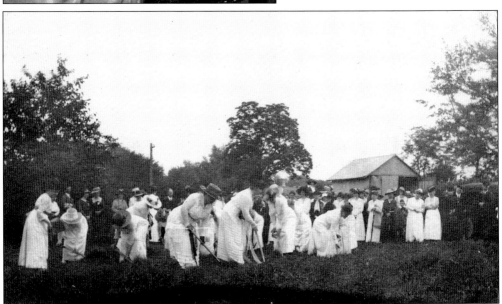

The Weidensall Hall groundbreaking, June 11, 1919, was a major event. The building, designed to foster Christian life at Pennsylvania College, was named in honor of Robert Weidensall (1836–1922), Pennsylvania College class of 1860 and father of the student YMCA movement in the United States.

Four

THE HANSON ERA
1923–1945

No president of Gettysburg College was more of a campus presence than Henry W. A. Hanson. Arriving at Gettysburg in 1923, when trustees lost confidence in the incumbent, Hanson sought to change the culture at Gettysburg College. And by most accounts, he accomplished his objective, putting a distinctive stamp on the institution.

A hale and florid character, Hanson worked along several tracks. During the 1920s—his years of serious accomplishment—Hanson revamped academic standards, hired strong department chairs, and oversaw campus expansion through the construction of a new gymnasium, chemistry complex, and library. Hanson's appointments to key academic posts—John Zinn in chemistry, Robert Fortenbaugh in history, and Thomas Cline in English were notable examples—infused those disciplines with energy and academic integrity. In athletics, Hanson gave Henry Bream a wide berth to build programs in football and basketball that would win games and build character. Bream did both.

Compulsory chapel was the main forum for Hanson's emphasis on building character. To some students he was the most important influence on their lives next to their parents. Others, wearying of Hanson's bromides, simply tuned him out.

Like its peers, Gettysburg College was affected by the tides of depression and war. Building ceased and the student body declined. Women were briefly denied the opportunity to matriculate at Gettysburg (1933–1935), but the closure of the preparatory division in 1935 provoked the trustees to rectify their mistake. During World War II, as most Gettysburg men volunteered or were drafted, President Hanson, desperate for tuition dollars, offered Gettysburg as a training ground for future officers. Air Force training programs proved valuable for those men, while keeping the college afloat.

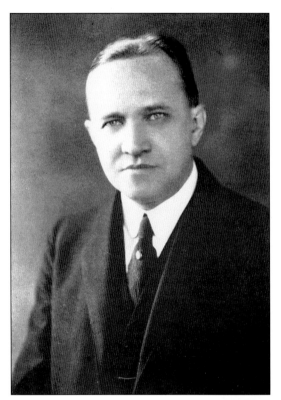

This photograph depicts Henry W. A. Hanson shortly after he arrived at Gettysburg in 1923, after a successful tenure as pastor of a large Lutheran congregation in Harrisburg. For the next three decades Hanson was the dominant figure on the Gettysburg campus. Early in his presidency Hanson dealt effectively with problems his successor had been unable to resolve. Later, buffeted by an economic depression and a world war, Hanson's leadership was less dynamic and less sensitive to the everyday needs of students and faculty.

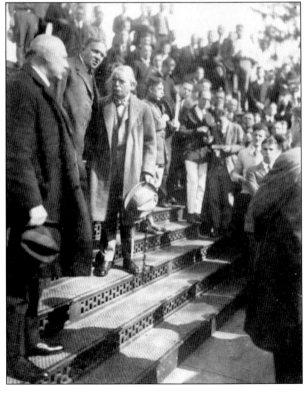

Through its history, Gettysburg has hosted many dignitaries. Among the more notable visitors to campus in the 1920s was David Lloyd-George, Great Britain's wartime prime minister. While on his American tour, Lloyd-George posed for pictures, but made no speech (on doctor's orders), on the steps of Pennsylvania Hall in 1923. At far left is Secretary of War John Weeks. Immediately to the left of Lloyd-George is President Hanson.

"DOC" ARMS "BILL" WOOD "HEN" BREAM

William (Bill) Wood was among the most successful and popular coaches at Gettysburg College. His football squads (1919–1927) regularly enjoyed winning records and at the same time were known for their sportsmanship. Wood was assisted by a young mathematics professor Richard A. "Doc" Arms. According to a *Gettysburg Times* article in 1924, Arms was the "sideline brain" who "mapped out plays" and deciphered the audible signals of the opposing team in time to relay the information to the Gettysburg bench. Wood left Gettysburg in 1927 to assume the head football coaching position at Wesleyan University.

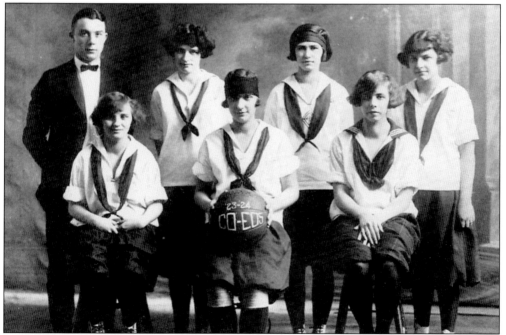

Henry Bream, Gettysburg's legendary coach (and later athletic director) began his career as an assistant to Bill Wood but also coached the women's basketball squad. Pictured above is the 1923–1924 coed basketball team.

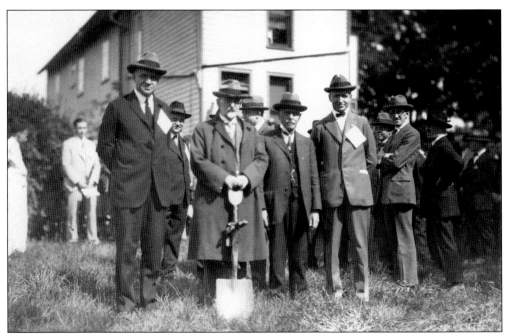

Prof. Edward S. Breidenbaugh wields the symbolic shovel at groundbreaking for a new science complex named for him in 1925. Work on the new Georgian-style brick building, which cost $160,000 to construct, proceeded slowly. It was dedicated on commencement weekend, 1929. Two years earlier, as the new science laboratories became operational in Breidenbaugh, the old McCreary Chemistry laboratory building, located immediately south of Weidensall Hall, was demolished.

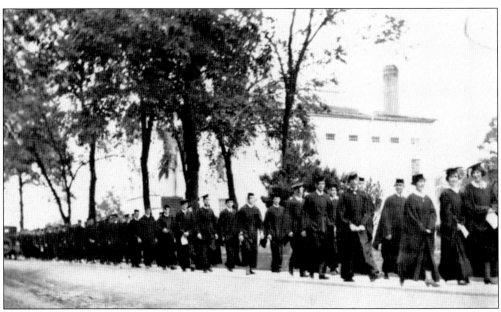

Commencement 1924 marked Henry W. A. Hanson's first full year as president of the college—and the 50th year on the faculty for professors Philip M. Bikle (Latin) and E. S. Breidenbaugh (chemistry). Above, students process en route to the graduation ceremony.

During the 1920s, students embraced a national trend and launched a humor magazine, the *Cannon Bawl*. The cover of the June 1926 number satirized a faculty warning that the students' humor was growing too bawdy and suggestive, which, if continued, would lead to a ban. There was no ban, but the magazine folded in 1928 having published fewer than a dozen issues.

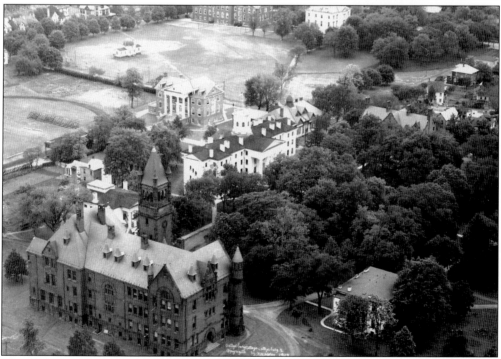

The first aerial view of the Gettysburg campus, this photograph was taken in 1925. Notice the college observatory on the site where the Hanson Residence Hall today stands.

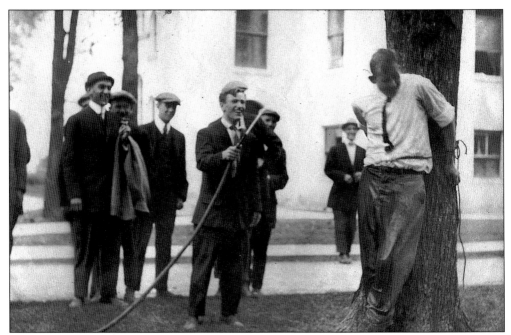

The Sophomore Band was history during the Hanson era, but upper class hazing of first year students was not. Above, sophomores soak a hapless freshman in front of Pennsylvania Hall around 1926.

This is an interior view of the Gettysburg Academy building lobby from about 1930, in what is best known today as Huber Hall. A preparatory department had been an integral part of the Gettysburg campus from the earliest days of the college. The academy continued to serve as a feeder school for Gettysburg College until it closed due to the financial exigencies of the Great Depression. The academy's final principal, Charles Huber (1871–1951), concluded his career as director of the college's newly reorganized women's division.

A 1926 production of Owl and Nightingale, the student theatrical troupe founded by Doc Arms, depicts a scene from the farce *Captain Applejack*. According to the *Spectrum*, the play offered "comedy with a romantic twist and an intricate plot."

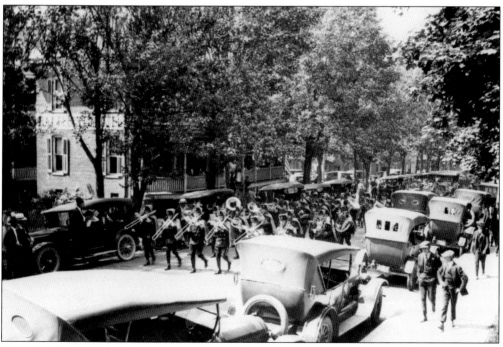

School spirit was exemplified in many ways. Above, Gettysburg students, led by the marching band, parade through town, presumably prior to a big football game, around 1925.

How did freshmen learn what was expected of them on campus? By memorizing the *G-Book*, which provided detailed information on what freshmen could and could not do, and what would happen if they committed an infraction. Typical punishments for men were haircuts administered on the steps of Pennsylvania Hall and being forced to parade on campus in outlandish outfits.

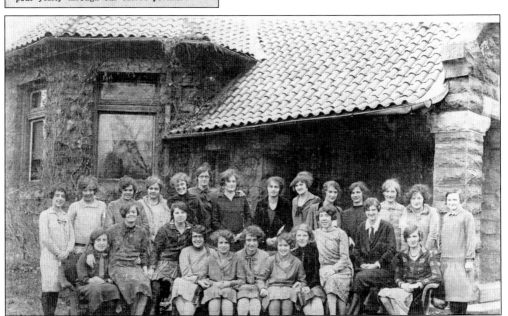

Sororities at Gettysburg have been a significant part of student life for women since the middle of the second decade of the 1900s. The first Greek letter organization for women to gain a charter was Beta Lambda (1916), which merged into the national Delta Gamma in 1939. Another local, Gamma Phi, was founded in 1923 and formally joined the national Chi Omega sorority in 1937. Above, the women of Gamma Phi pose in front of their sorority house, Glatfelter Lodge, around 1928.

Student pranks were long a staple of college life, and sometime faculty and administrators were the targets. In this photograph from the 1932 *Spectrum*, "A conscientious professor" is hanged in effigy from the cupola of Pennsylvania Hall.

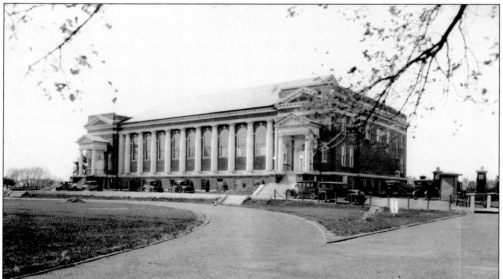

As President Hanson's vision for a greater Gettysburg gained momentum in the 1920s, a new gymnasium was deemed essential. Plans were well under way for a modern basketball facility on the west side of the campus when baseball great Eddie Plank died. The building, designed by George C. Baum '93 (also the architect of Weidensall Hall), was financed in part through a major league exhibition game featuring Plank's old team, the Philadelphia Athletics. Plank Gym was dedicated during commencement week, June 1927.

This view of the west side of the college campus, around 1929, overlooking Nixon baseball field offers a unique perspective of the campus. Plank Gym is in view on the left side of the photograph, Lincoln Street on the right.

Among beautification projects launched by President Hanson was the Memorial Gardens, on the east side of North Washington Street, roughly the site of today's college chapel. This photograph was taken late in the summer of 1929. Notice Weidensall Hall on the far left and Breidenbaugh Hall on the far right.

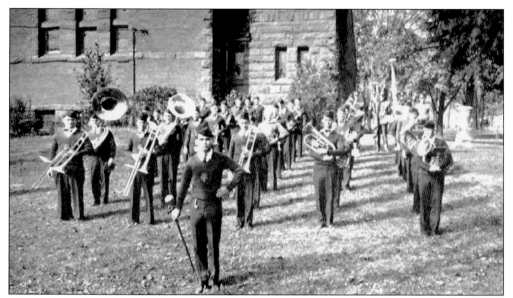

The college band poses for a photograph in 1929. Formed in 1910, the band was then directed by engineering professor Bertram Saltzer, who also directed the college orchestra from 1925 to 1940.

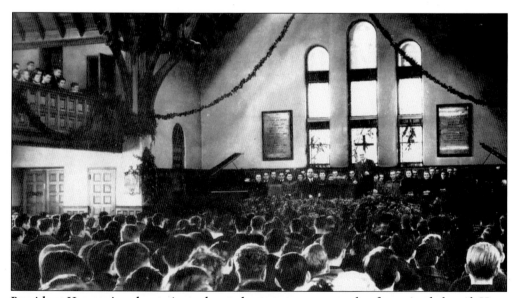

President Hanson's exhortations about character were a staple of required chapel. Here the president stands addressing the student body in Brua Chapel in the late 1920s, surrounded by the college faculty. Dean Wilbur Tilberg is to his right in the front row, facing the students.

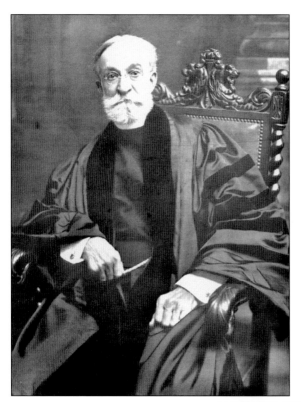

One of Gettysburg's most distinguished alumni and generous benefactors was Rev. Jeremiah Zimmerman '73 (1848–1937). A Syracuse clergyman, world traveler, and author, Zimmerman donated his enormous collection of books, maps, and paintings—some 70,000 items—to the college specifically to fill the new library. Thousands of Zimmerman's books remained uncataloged as late as the 1960s. Others were given away. No one knows what percentage of these materials remain in the library collection today.

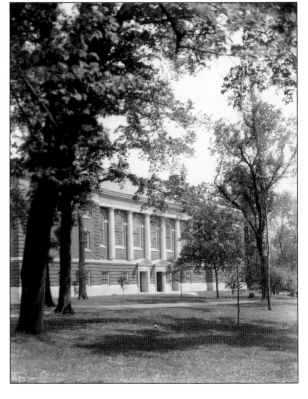

The new library, opened in November 1929, was a Georgian-style building designed by architect Alfred Hamme '18. A centerpiece of Henry Hanson's plans for an expanded campus, construction was launched thanks to a major gift promised by trustee Henry Weber in memory of his late wife Emma. Weber never made good on his pledge and the college named the library in 1957 for founder Samuel Simon Schmucker. Today it houses the Music Conservatory and the Department of Visual Arts.

In a move the trustees came to regret and were forced to reverse, it was determined in 1930 to turn Gettysburg into an all-male college. This picture captures the "magnificent seven" women graduates of the class of 1933—whose departure was expected to close a notable chapter in Gettysburg coeducation. The impact of the Depression, which provoked the closure of the preparatory department in 1935, led the trustees to readmit women and provide housing for them in Huber Hall.

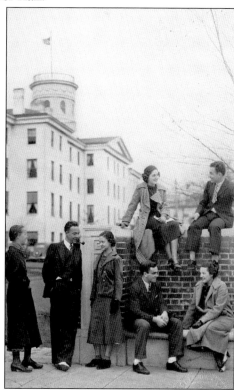

It did not take long for Gettysburg to adjust to coeducation, as this publicity photograph, featured in the 1937 *Spectrum*, suggests. Stylish students posed, with a timeless building as the backdrop.

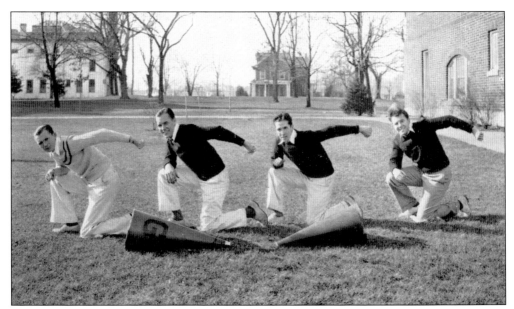

In the absence of women students, male cheerleaders complemented the athletic program. This photograph depicts the 1934–1935 cheerleader squad expressing Gettysburg spirit.

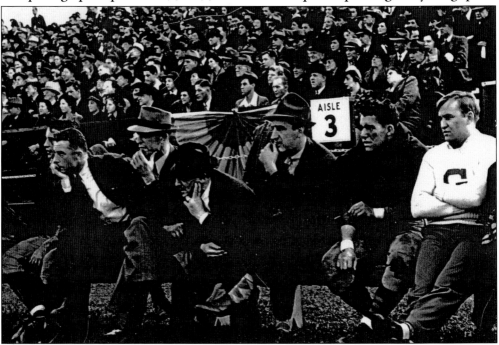

For sheer anticipation and excitement during the Hanson era, few events matched a home football contest. The picture above captures a pivotal moment as coach Hen Bream, assistant coach Pete Beeson, trainer Romeo Capozzi, Russ Gilbert, and two students follow a particularly tense set of downs. If Gettysburg won the game, the Glatfelter Hall bell would peal and excited students would gravitate to the White House, chanting "Monday off, Monday off." With characteristic flourish President Hanson usually granted the request, eliciting cheers.

Few Gettysburg faculty exerted more influence over a longer period than professor of chemistry John B. Zinn '09. Shown here during World War II in his patented lab coat, Zinn mentored generations of students and pointed many of them to careers in medicine. Zinn would match the student with the medical school and make a phone call to the school's dean. More often than not the Gettysburg student gained admission.

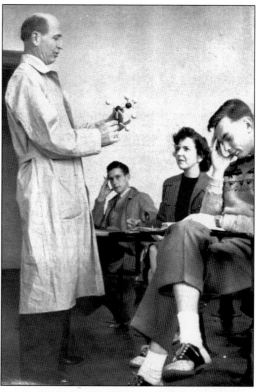

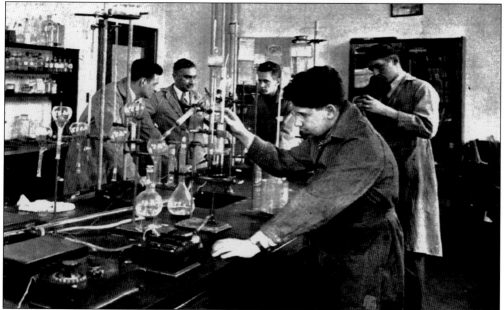

Throughout the 20th century, Gettysburg College prided itself on the strength of its chemistry program, which produced many notable chemists and doctors, among other useful citizens. This 1937 photograph catches students conducting an experiment in a Breidenbaugh Hall laboratory. They were working under the supervision of Prof. Charles Sloat '23, pictured second front left, in the background.

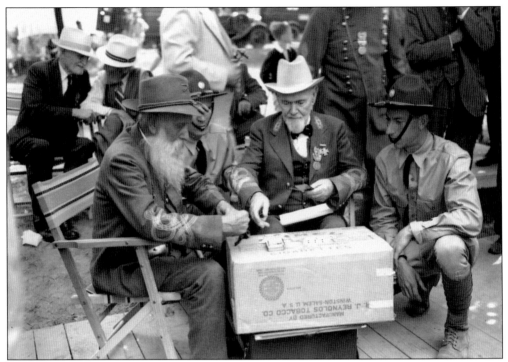

The Gettysburg campus served as the headquarters for the final reunion of the Blue and the Grey in 1938—the 75th anniversary of the Battle of Gettysburg. The veterans lived in tents, their needs tended to by local Boy Scouts, among them was Robert Fortenbaugh '44, son of the chair of the college history department. Here old warriors play cards in the quad on the north side of Pennsylvania Hall.

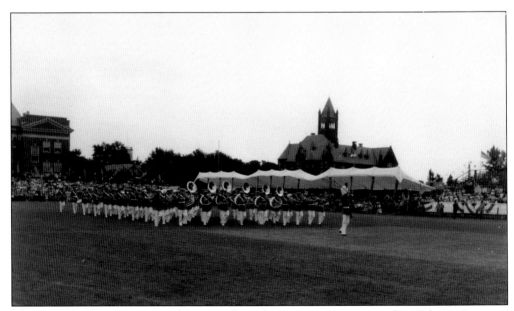

The United States Army Marching Band strides across campus on the 75th anniversary of the Battle of Gettysburg, July 1938.

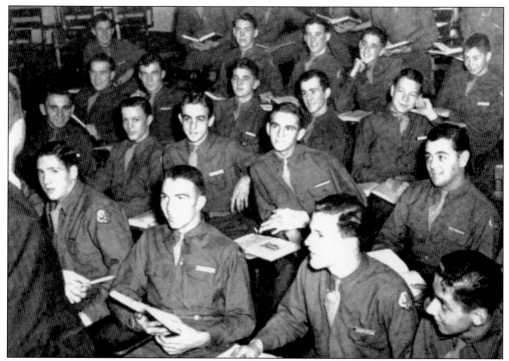

World War II laid upon Gettysburg College, as Henry Hanson later put it, "a succession of interesting problems and unique opportunities." A cocoon no more with the onset of the war, Gettysburg College survived the exodus of male students in part with programs for pre–Air Corps Cadets from March 1943 through May 1944, and later, ASTRP candidates who studied for up to a year at the college before heading overseas. Here Air Cadets pay apt attention to their instructor before heading outdoors for physical training.

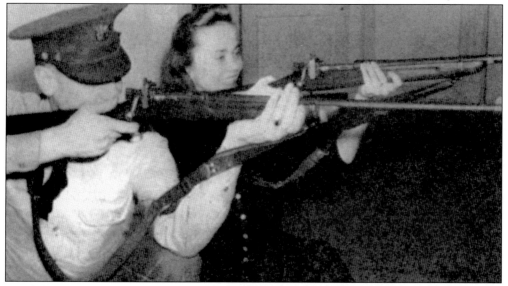

Coed fraternizing with the cadets was officially frowned upon, but it was a regular part of campus life, including, as this picture shows, some target practice at the Phi Delta Theta House.

CAMPUS CAPERS
of
GETTYSBURG COLLEGE

Although the war disrupted many of the normal activities at the college—including suspension of intercollegiate football—many pre-ministerial and pre-medical students, 4-Fs, and a growing cadre of women attempted to maintain as much normalcy as possible.

"Campus Capers," drawn by R. Leon "Lee" DeGroot '46 for the end papers of the 1944 *Spectrum*, depicts a lively campus scene.

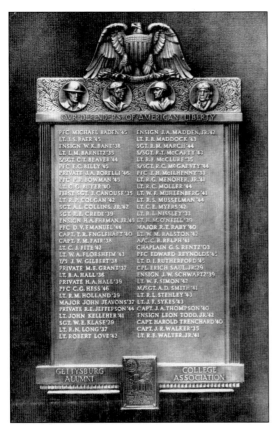

Gettysburg contributed materially to the war effort, not least through the efforts of its sons on the battlefield. In 1946, the alumni association funded this plaque to memorialize those Gettysburg alumni who made the supreme sacrifice for their country.

OUR DEFENDERS OF AMERICAN LIBERTY

PFC MICHAEL BADEN '45	ENSIGN J.A. MADDEN, JR. '42
LT. J.S. BAER '45	LT. E.R. MADDOCK '43
ENSIGN W.K. BANE '38	SGT. R.M. MARCH '44
LT. L.M. BARNITZ '35	S/SGT. R.T. McCARTY '43
S/SGT. C.T. BEAVER '44	LT. R.F. McCLURE '35
PFC E.C. BILLY '45	S/SGT. R.C. McGAFVEY '44
PRIVATE J.A. BORELLI '46	PFC J.H. McILHENNY '33
PFC P.R. BOWMAN '45	LT. R.G. MENOHER, JR. '41
LT. G.G. BOYER '40	LT. R.C. MOLLER '44
FIRST SGT. J. CANOUSE '35	LT. W.F. MUHLENBERG '41
LT. R.P. COLGAN '42	LT. R.S. MUSSELMAN '44
SGT. A.L. COLLINS, JR. '42	LT. C.E. MYERS '42
SGT. R.E. CREDE '39	LT. R.L. NISSLEY '33
ENSIGN H.A. EHRMAN, JR. '43	LT. H.M. O'NEILL '39
PFC D.V. EMANUEL '44	MAJOR R.T. RABY '40
CAPT. T.R. ENGLEHART '40	LT. W.M. RALSTON '47
CAPT. F.M. FAIR '38	A/C. C. R. RELPH '41
LT. C.J. FITE '42	CHAPLAIN G.S. RENTZ '03
LT. W.A. FLORSHEIM '43	PFC EDWARD REYNOLDS '45
T/5 J.W. GILBERT '38	LT. D.I. RUTHERFORD '45
PRIVATE M.E. GRANT '37	CPL. ERICH SAUL, JR. '29
LT. B.A. HALL '36	ENSIGN J.W. SCHWARTZ '39
PRIVATE H.A. HALL '39	LT. W.F. SIMON '42
PFC C.G. HESS '46	M/SGT. A.D. SMITH '41
LT. R.M. HOLLAND '39	LT. R.L. STEHLEY '43
MAJOR JOHN JEAVONS '37	LT. J.F. SYKES '43
PRIVATE R.E. JEFFERSON '44	CAPT. J.A. THOMPSON '40
LT. JOHN KELLEHER '41	ENSIGN LEON TODD, JR. '42
SGT. W.E. KLASE '29	CAPT. HAROLD TRENCHARD '40
LT. R.N. LONG '37	CAPT. J.R. WALKER '35
LT. ROBERT LOVE '42	LT. R.E. WALTER, JR. '41

GETTYSBURG ALUMNI COLLEGE ASSOCIATION

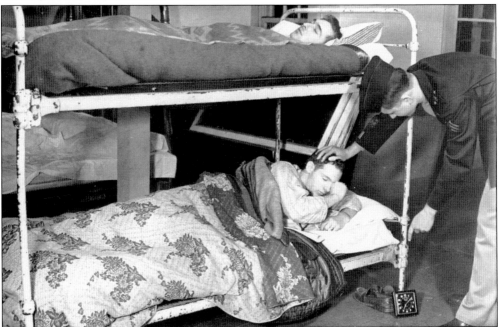

This photograph from the 1944 *Spectrum*, could well be titled "Waking Up at 6 a.m. is Hard to Do." It captures an Air Force cadet being reminded of the arrival of a new day.

Five

PROSPERITY AND GOOD TIMES
1945–1961

Thanks to government funding of military training programs, Gettysburg College survived the Second World War intact, but its future was no sure bet. To the surprise of college officials, Gettysburg, in 1945 and subsequent years, enrolled far more students than expected, many of them veterans using GI Bill benefits. So many students enrolled that new faculty were hired and temporary structures—for example the barracks on the site of the present-day CUB—were required to handle the influx.

The years between 1946 and 1961 were good times for the college. Enrollment rose from fewer than 600 students in 1945 to nearly 1,800 by 1961, necessitating an expansion initiative. A 1,200-seat chapel was dedicated in 1953. Brua Chapel was remodeled as a music complex, and dormitories along Lincoln Street were erected during the brief but productive administration of Gen. Willard S. Paul. In 1959, a new student union building, featuring bowling alleys, a swimming pool, bookstore, and ample meeting space, became a centerpiece of campus life.

No single generalization can define students' values and priorities in any era. There are always those for whom college was an intellectual feast. For others, college years afforded opportunities for social networking and high jinks. If ever Gettysburg College was identified as a school dominated by athletic pursuits and Greek life, this was the period. National publications hailed Gettysburg's fraternity system as a model. Most Gettysburg students embraced Greek life and its accoutrements—the big game, the big weekend, and Greek Week fun. Not even the emergence of a new movement for civil rights or the heating up of the Cold War, as a Soviet leader promised to "bury" America with its economic advance, could break most students out of their four-year idyll. The remarkable thing is how many of them went on to distinction in their respective fields of endeavor, as notably exemplified by Michael Bishop '57, winner of a Nobel Prize in Medicine.

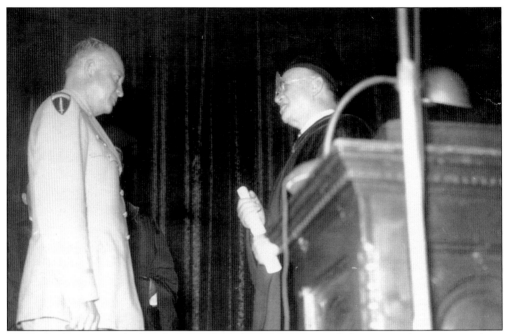

No event better symbolized the end of the war years and the start of a new era than the college's conferring an honorary degree on supreme Allied commander in Europe Dwight D. Eisenhower at commencement on May 27, 1946. The general stands at attention as Pres. Henry W. A. Hanson extols his virtues. Eisenhower then addressed graduates in the Majestic Theatre, highlighting challenges facing the rising generation and his confidence in America's youth.

An autumn tableau, with Brua Chapel as backdrop, is seen here in the late 1940s.

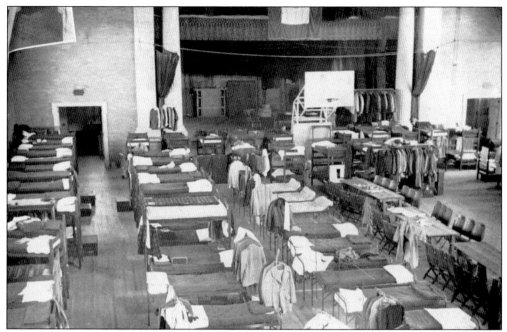

Veterans using the GI Bill engulfed Gettysburg College, beginning in the fall of 1945, doubling the student body and forcing college leaders to scramble to find adequate housing. In the first weeks of the academic year 1945–1946 dozens of returning vets were forced to bunk in Plank Gym.

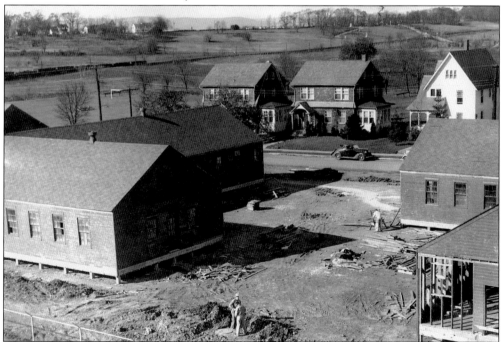

By mid-autumn 1946 seven barracks along Lincoln Street were in service. Designed for 200 men and 11 GI families, the barracks were built with federal funds. They remained a part of the campus landscape until 1957.

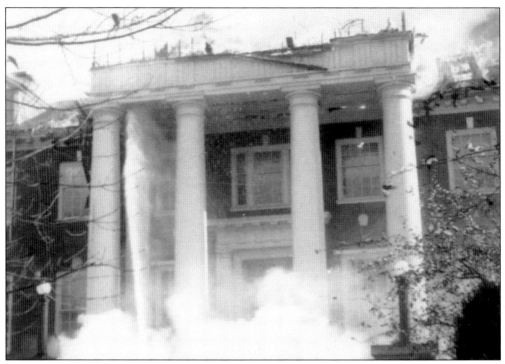

On November 23, 1946, Weidensall Hall burned down in a spectacular blaze that left only the core of the building intact. This photograph captures the moment when the roof of the building began to collapse.

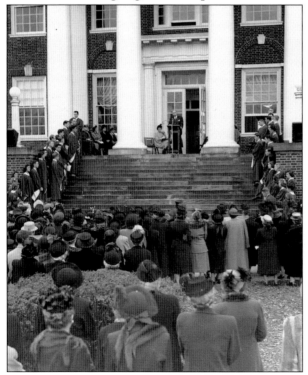

By 1948, Weidensall Hall—the SCA building for a quarter-century—was back in business. Here President Hanson, flanked by the college choir, formally rededicates the building. Ethel Wickey '16, president of the Woman's League, received the keys of the renewed structure from architect J. Alfred Hamme '18 and presented them to President Hanson.

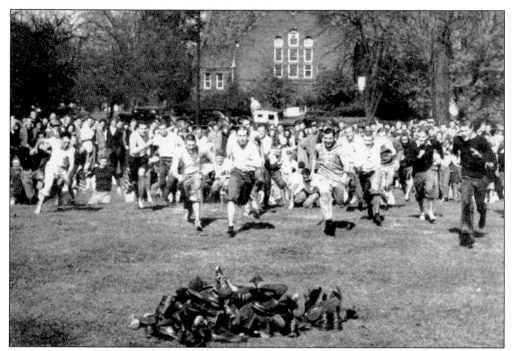

Freshmen race to the shoe pile as part of customs in 1948.

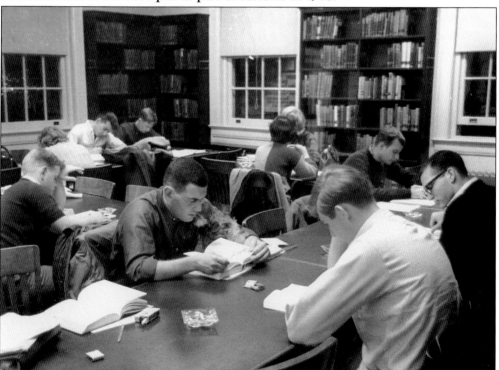

This is a scene from the smoking room in Schmucker Library in the 1950s. Students relieved their stress by dragging on a cigarette or pipe while hitting the books—a sight unlikely to be seen again in the college library.

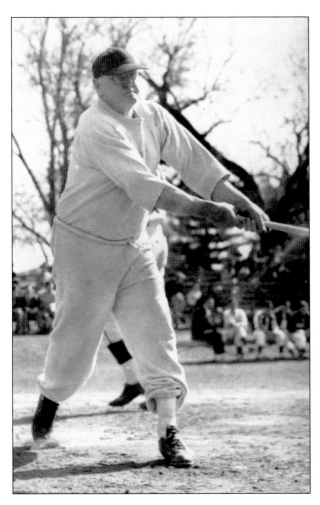

Except for a brief break during World War I, for 38 years (1913–1951) Gettysburg's baseball squad was coached by Ira Plank, brother of Baseball Hall of Fame pitcher Eddie Plank. Plank was photographed in his final year as coach, hitting grounders to his infielders before a game.

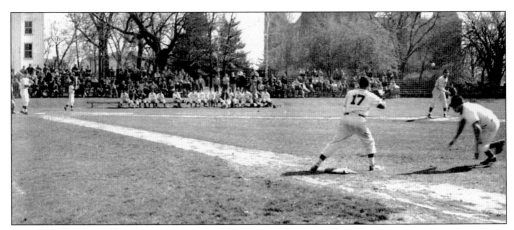

A pick-off play in the 1952 season on Nixon Field is seen here.

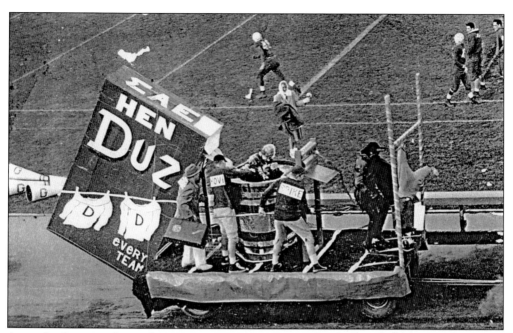

A regular feature of every homecoming weekend was a football game and a halftime show that included hand-crafted floats, often with a humorous theme. This float expressed popular sentiment about Hen Bream's impact as a coach.

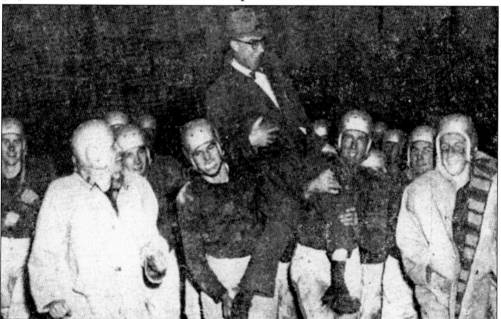

No Gettysburg coach enjoyed more consistent success or was more popular than Henry "Hen" Bream '24. Best known for his football teams, which won 104 of 185 games, Bream was equally successful on the hard boards. In a memorable finale to 25 years of football coaching, Bream's boys defeated Franklin and Marshall College in the traditional Thanksgiving Day contest in 1951, by a 40–20 score on Franklin and Marshall College's home field. Bream was carried off the field by his exultant players.

In 1952, after 29 years as Gettysburg's president, Henry W. A. Hanson retired. He was succeeded by a distinguished European historian, then head of Wagner College on Staten Island, Walter Langsam. Langsam's tenure at Gettysburg was brief, productive, and turbulent. Hanson loyalists found it difficult to accept changes that Langsam believed necessary for Gettysburg to move forward in a new era. Their carping wore him down. In 1955, Langsam accepted the presidency of the University of Cincinnati, where he served for 17 years.

Supervised by Julie Langsam, the president's spouse, Gettysburg students engage in a cleanup project, immediately east of the new chapel building and west of the president's house, during the spring of 1954.

The college choir recessional concluded the consecration service of the new chapel, designed by college architect Alfred Hamme and built at a cost of nearly $600,000.

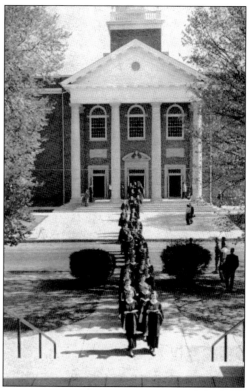

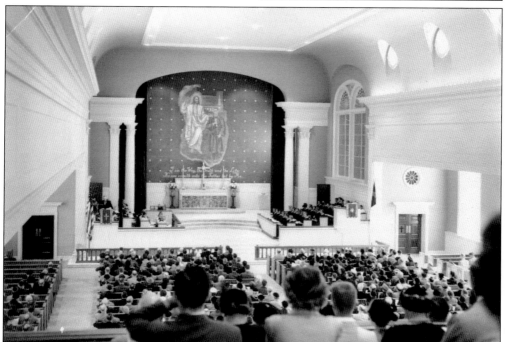

A highlight of Walter Langsam's presidency was the dedication of Christ Chapel on October 17, 1953. Chaplain Edworth Korte led services at the dedication, at which President Emeritus Henry W. A. Hanson delivered the homily.

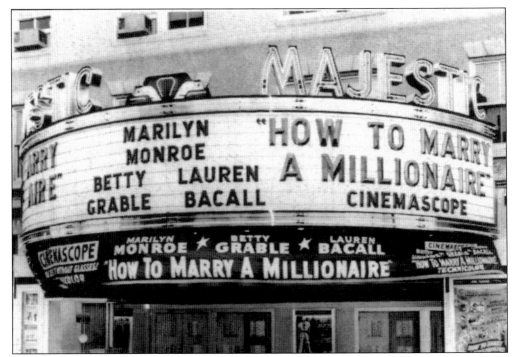

A typical weekend activity for Gettysburg students in the 1950s might entail a visit to the Majestic Theatre for the latest Hollywood flick. Marilyn Monroe received top billing in *How to Marry a Millionaire*, which played at the Majestic in 1953.

A popular campus tradition of decorating fraternities at Christmas reached an apogee in the 1950s, as exemplified here, in 1957, at the Lambda Chi Alpha House.

Gettysburg women gather for animated conversation in a cheerful residence hall setting in 1952.

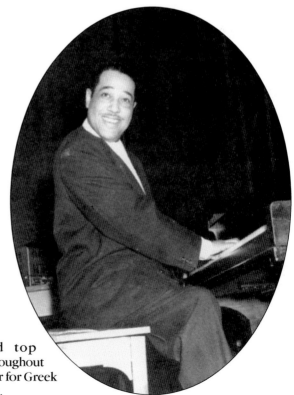

Gettysburg students enjoyed top entertainment at special weekends throughout the postwar era. In 1951, the headliner for Greek Week was jazz great Duke Ellington.

The presidency of Willard S. Paul (1956–1961) was marked by campus construction. The Charles Stine freshman dormitory, named after a distinguished alumnus and longtime board chairman, was built in 1955. Completion of the first year mens' quad took several more years. In this photograph Rice Hall and Paul Hall construction is captured in progress around 1958.

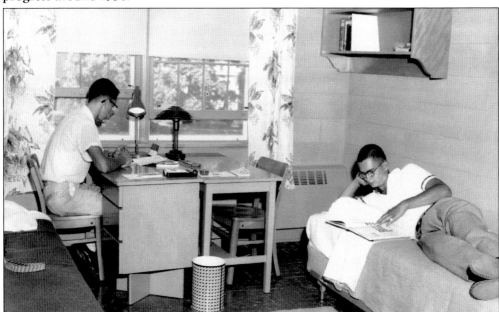

The interior of the new freshman dormitories was spartan by today's standards, but comfortable enough for Stephen Munzinger '61, seated at left, and Sherman Hendrix '61 in Dorm B—soon to be named Rice Hall in honor of John S. Rice '21, a former Pennsylvania state senator and cabinet officer in the administration of Gov. George Leader '39. Rice later served the Kennedy Administration as ambassador to the Netherlands.

Robert Fortenbaugh '13 was among the most influential members of the college faculty for more than three decades. Fortenbaugh founded the modern history department, which he chaired for 36 years. He also served as one of the triumvirate (together with trustee John Rice and college dean Seymour Dunn) that ran Gettysburg College during its "year without a president" (1955–1956). In 1961, a new lectureship on Civil War topics at Gettysburg was named for Fortenbaugh.

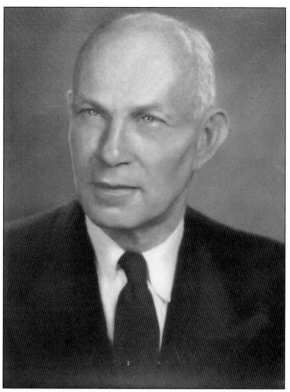

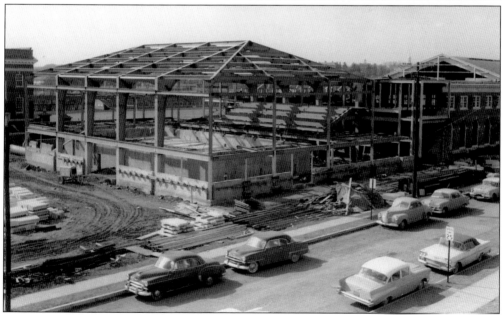

Funded mainly by low-interest federal loans, the college's then state-of-the-art student union building, located just north of Plank Gym and Memorial Field, would house on completion in 1959 a modern swimming pool, game room, meeting places, snack bar, bookstore, post office, and barbershop, among other amenities. The SUB (Student Union Building), as it was long called, is shown during construction in the spring of 1958.

Pictured here is a slice of everyday life in Glatfelter Hall that generations of alumni will recall; changing classes. This picture was taken during the late 1950s.

Librarian Lillian Smoke, standing at center and far right in this photograph, instructs first year students on the "rules of the road" in Schmucker Library, around 1960. Notice the "dinks" and the students' names and home towns on placards they were required to wear during orientation week and often for a week or more beyond orientation.

A periodic visitor to Gettysburg College during his presidency, Dwight D. Eisenhower maintained an office in Glatfelter Hall during his recuperation from a serious heart attack in 1955. In the spring of 1959, the president spoke on campus at Willard Paul's invitation on the prospects for thawing the Cold War. Ike followed up by inviting Soviet premier Nikita Khrushchev to visit the United States that summer, an invitation Khrushchev accepted. Pictured here, seated behind Ike, is trustee chairman John S. Rice.

Although Gettysburg students may have focused heavily on their studies and having a good time at college, they had ready access to lecturers who analyzed contemporary issues relating to peace, war, poverty, and urban decline. Here the famed author of *A Study of History*, Arnold Toynbee, receives an honorary degree from President Paul before speaking at the annual founders' day convocation on April 7, 1961.

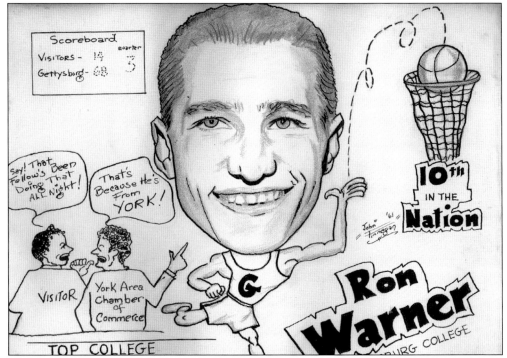

Ron Warner '62 was probably the greatest basketball player ever to don an orange and blue jersey. Standing less than six feet tall, Warner set records for foul shots in one game (22 out of 22) and total career points: 1,880 during three years of varsity play. He was named All State and All East for two straight years and was twice named Middle Atlantic Conference Most Valuable Player, among other honors. Warner's achievements were noted by a newspaper artist from York, his home town.

Before a series of storms toppled trees and thinned out foliage in the Old Quad in the 1960s, the Gettysburg campus took on the aura of an arboretum. Mother Nature showcases some of her finest handiwork on campus during spring 1947.

Six

TRIALS AND TURBULENCE
1961–1977

Gettysburg College embraced the 1960s with a nod to John F. Kennedy's "New Frontier," but with a fundamentally conservative outlook. Fraternities dominated campus social life and intercollegiate football action absorbed student energies on autumn weekends. Comprising one-third of the student body for most of these years, coeds faced a range of parietal rules about curfews and entertaining male company. Few questioned, much less protested, the status quo.

Yet the college was not immune to the impact of the Vietnam War or a nascent revolution of manners and morals. By the mid-1960s, students and faculty members began challenging conventional wisdom about America's role in Southeast Asia, as others protested the double standard of male freedom of movement while women faced required "hours." Hair grew longer and pant legs widened. Meanwhile football's hold on the campus culture declined. In many a dorm and class room, debates were enjoined over Pres. Richard Nixon's Vietnam policy. Student life was indelibly affected by the increasing availability of controlled substances and birth control. Gettysburg in the 1970s was a different school in key respects than it had been only a decade previous.

Two figures guided the institution through stormy weather. First was Pres. Carl Arnold Hanson, who assumed duties in 1961 having served as dean of the College of Arts and Sciences at Cornell University. Hanson dissuaded conservative trustees from cracking down on student dissent and affirmed the institution's commitment to intellectual freedom and the right to protest. The opposite of charismatic, Hanson led by example with his simple decency. His close associate, also recruited from Cornell, was Chaplain John "JV" Vannorsdall. JV, as he was affectionately known by a generation of Gettysburg students, provided wise counsel and a haven for questioners, activists, and the disaffected.

During the Hanson years, new, architecturally mediocre buildings were erected, among them Masters Hall (physics) and McCreary Hall (life science). Musselman Stadium was dedicated in 1965 and campus boundaries were extended. Symposium 1970 demonstrated Gettysburg's commitment to engaging hot-button contemporary issues. But President Hanson's main legacy to his successor was a college community that held together when so many campuses came apart.

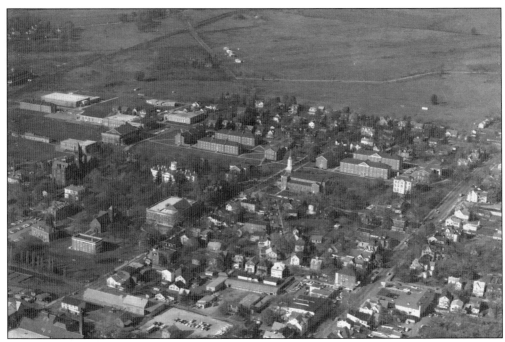

This aerial view of Gettysburg College and the surrounding community was taken in the early 1960s, as the student population was moving towards 1,800 and the campus was growing to meet new needs.

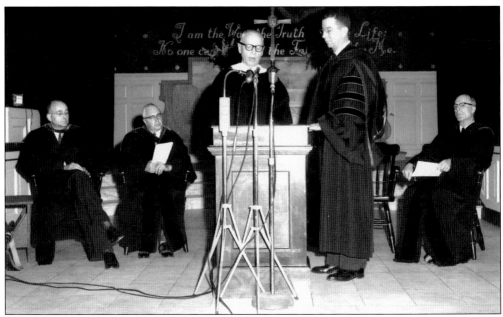

C. Arnold Hanson, dean of the College of Arts and Sciences at Cornell University, was installed as Gettysburg College's 10th president early in 1962. Hanson accepted a charge from trustee John A. Apple '19 as psychology professor Kenneth Smoke (far left) and officers of two Lutheran Synods looked on. Hanson served the college with modesty, forbearance, and tact from 1961 until 1977.

Generations of Gettysburg students have exploited their access to the battlefield for recreation and, occasionally, study time. Here students work on assignments during an early spring day at Devil's Den in 1965.

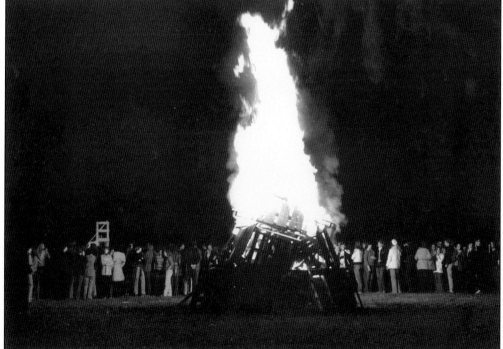

During the early 1960s, the traditional bonfire before a big home football game remained the norm.

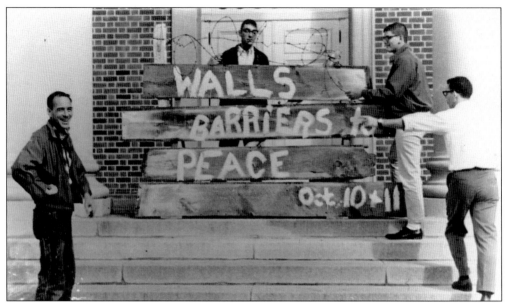

Few individuals influenced students more profoundly in the 1960s than Chaplain John "JV" Vannorsdall, captured at far left with chapel council members around 1966. During the Vietnam War, Vannorsdall helped keep the lid on the campus by channeling student energies into non-violent protest. Vannorsdall subsequently served as chaplain at Yale College, succeeding William Sloane Coffin, and as president of the Mount Airy Seminary of Philadelphia.

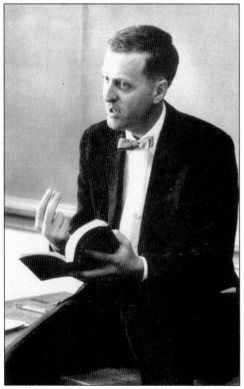

One of Gettysburg's most popular and versatile faculty members in a career spanning five decades (1956–2006), religion professor Louis Hammann rode the wave of student interest in eastern philosophy and religion during the late 1960s. His classes helped broaden and redefine the department's focus.

Richard T. Mara was a widely respected member of the college faculty during the Hanson and Glassick presidencies. As chair of the Department of Physics during the post-Sputnik era, Mara grew the department, added astronomy to the curriculum, and attracted substantial federal dollars to the physics program.

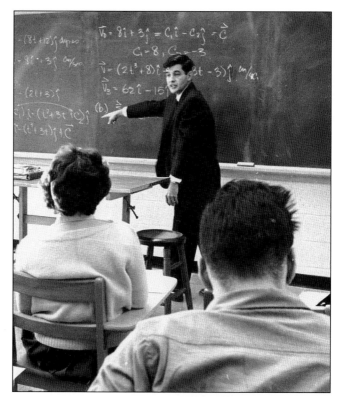

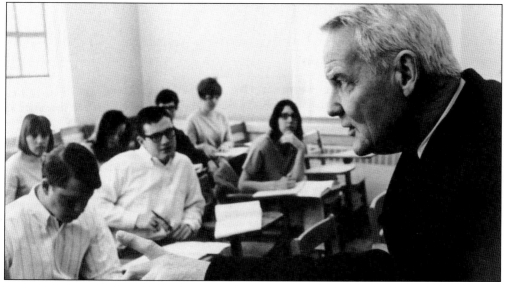

Charged with finding an archetypal professor, central casting could not have improved on Norman E. Richardson. But appearance was not the defining element of Richardson's impact on campus from 1946 to 1979 as philosophy department chair. His infectious enthusiasm, expressive eyebrows, and emphasis on constructing a workable "philosophy of life" proved catnip for students. One measure of their respect for him was students' insistence in 1969 on bringing Richardson back to Gettysburg from a sabbatical appointment at the University of California to address an all-campus moratorium.

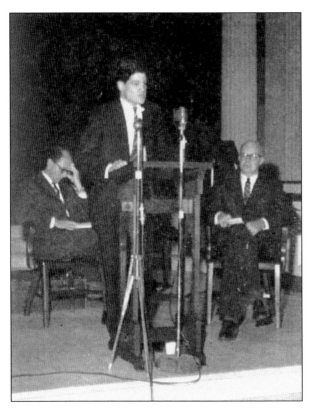

Gettysburg College embraced the Civil War Centennial with a range of activities, from scholarly conferences to anniversary convocations. In November 1963, the college and the Civil War Centennial Commission collaborated on a three-day program marking the 100th anniversary of Abraham Lincoln's visit to Gettysburg. Left, George Muschamp '66 recites the Gettysburg Address, as history professor Robert L. Bloom (right) and Columbia University historian David Donald look on.

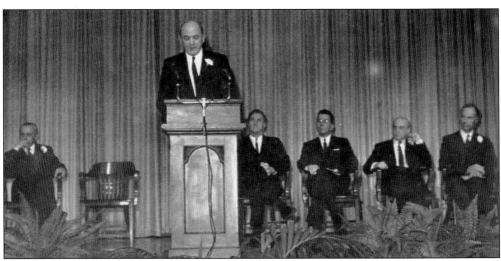

Secretary of State Dean Rusk delivered the keynote address to a capacity crowd in the student union building in November 1963, launching the long-planned Civil War Centennial conference. Seated behind Rusk from left to right are Amb. Sergio Fenoaltea of Italy, Lt. Gov. Raymond P. Shafer of Pennsylvania, college president C. A. Hanson, Amb. Herve Alphand of France, and British embassy minister John Chadwick.

While clinging to traditions in the early 1960s, Gettysburg nonetheless was open to new currents in the arts, as evidenced by this activities board from around 1964.

One of Chaplain John "JV" Vannorsdall's efforts to bring more of the real world to Gettysburg College was an exchange program with a predominantly black institution in Tennessee. The so-called "Knoxville exchange" commenced in 1965 and ran for three years. Here Knoxville College students, on campus in November 1966, get oriented to Gettysburg.

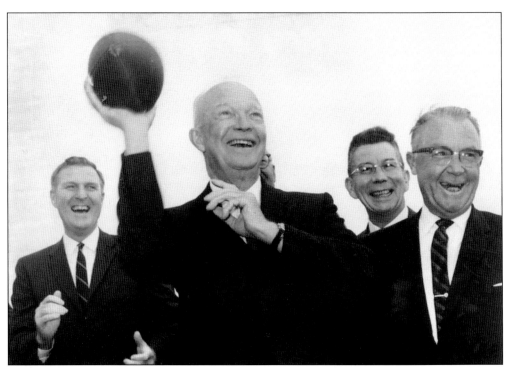

Former Pres. Dwight D. Eisenhower tossed the ceremonial first football at Musselman Stadium's dedication in September 1965. Cheering him on from left to right are Pennsylvania's Lt. Gov. Raymond Shafer, college president C. A. Hanson, and athletic director Hen Bream.

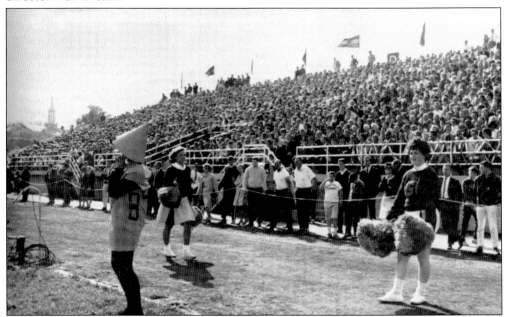

A capacity crowd filled Musselman Stadium on its dedication day in 1965. The weather was perfect, the pageantry splendid—but the visiting Bucknell Bisons went home with the Charles H. Huber traveling trophy.

Gettysburg football attracted notable talent during the Hen Bream era and beyond. The mid-1960s was a particularly vibrant era, featuring stars such as quarterbacks Jim Ward and Dick Shirk and their favorite target, end Joe Egresitz, pictured at right. In 1966, Egresitz was named to the Little All-American team and the All State team, as coaches of the Middle Atlantic Conference designated him the conference's most valuable player.

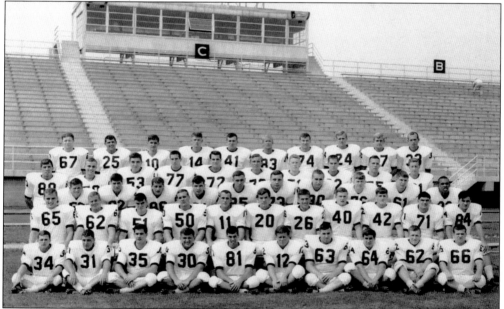

Quarterback Dick Shirk led the 1966 football squad, coached by Eugene Haas, to a 7–2 record and the Lambert Cup, as the premier team in Eastern small college football. It would be more than a decade before Gettysburg would regain standing as a highly competitive football program—something it accomplished early in the long tenure of coach Barry Streeter.

A popular ritual for generations of fraternity men was the dousing of brothers who "pinned" their sweethearts—a step beyond going steady but short of engagement. Here, in a 1961 photograph, Tau Kappa Epsilon (TKE) brothers throw one of their own into the quarry.

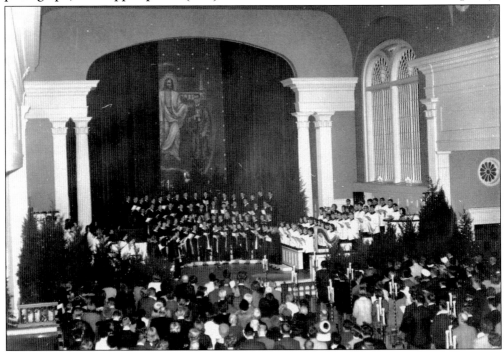

A regular feature of each academic year into the mid-1960s was Religious Emphasis Week, which often drew large crowds to the college chapel. A 1965 photograph captures a scene no longer on view—religious art commissioned by Pres. Henry W. A. Hanson.

Into the late 1960s, entering first year students were expected to wear "dinks" and identify their home towns during orientation. Above, students chow down near the quarry in September 1968.

Although the Vietnam War was at its peak, dividing the campus and the nation into pro and antiwar factions, all was not politics or polemics at Gettysburg College. Many traditions continued to thrive. Here the sisters of Chi Omega gather for tree trimming and a visit with Santa in December 1967.

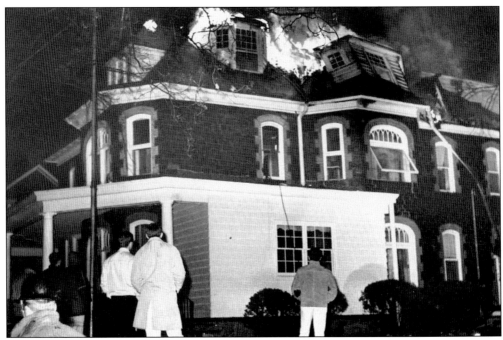

Phi Delta Theta house, operated by one of the college's leading fraternities, went up in flames in November 1967. It was soon rebuilt.

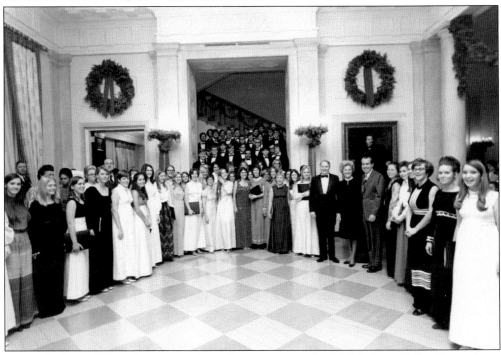

Since the late 1930s, choir tours have been among the highlights of the Gettysburg experience for many students. Few outside engagements could top that of December 1969 as the college choir, led by its founding director Parker Wagnild, performed at the White House. Pres. Richard M. and Patricia Nixon posed with Wagnild and his students.

Long distance runner Tom Ratliffe '68 was one of Gettysburg's greatest track athletes. Here Ratliffe leads the pack in yet another winning performance in the spring of 1968.

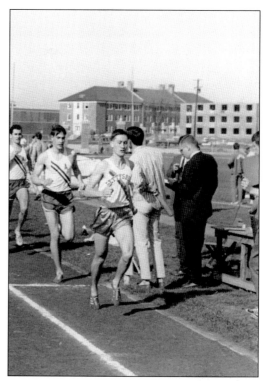

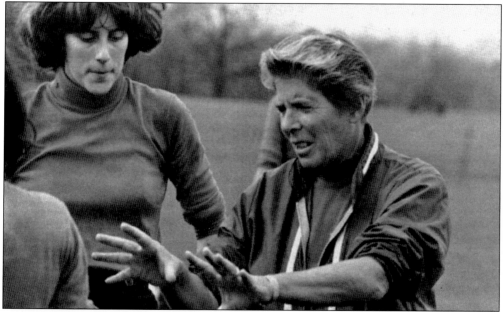

Known not just as a fine coach but as a champion for women's athletics during an era when women were not always taken seriously as competitors (nor allotted a reasonable share of athletic resources), Grace Kenney left an indelible legacy. Operating on no-frills budgets, her teams over four decades, particularly in field hockey and lacrosse, compiled impressive win-loss records and produced a host of All Conference and All-American athletes.

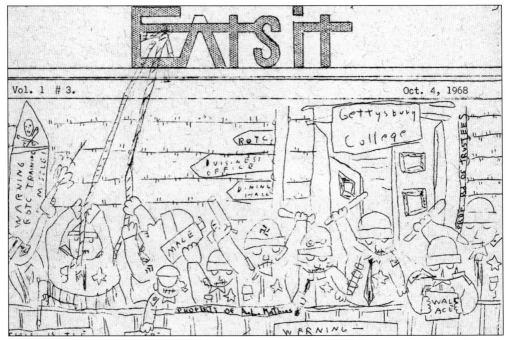

Vol. 1 # 3.

Oct. 4, 1968

In a turbulent era, alternative media on campus were part of the campus scene. Among the most controversial, albeit short-lived, publications was *Eatsit*, edited by Steve Litwack '69, which annoyed the administration and outraged many of the college's conservative alumni.

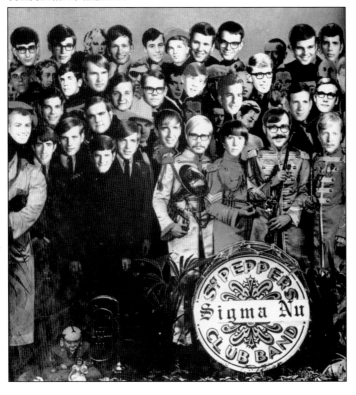

Sigma Nu Fraternity, in tune with the Zeitgeist, posed for the 1970 *Spectrum* in the guise of Sergeant Pepper's Lonely Hearts Club Band.

Biology major David Hartman '72 made news when he was accepted to Temple Medical School. Ordinarily this would not be a major story but for the fact that Hartman had been blind since the age of 8. He was the first sightless person accepted to an accredited medical school in the 20th century. Hartman graduated from Temple and went on to a successful career as a psychiatrist in Roanoke, Virginia, where he still practices. Here Hartman is shown working on an experiment with biology professor A. Ralph Cavaliere.

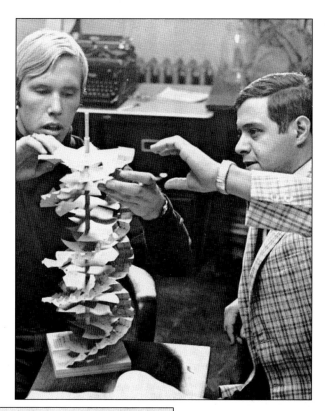

Gettysburgian

Gettysburg College
Gettysburg, Pa. 17325

Vol. LXXXII, No. 9
November 15, 1968

Forum Defends Liberalized Hours, Self-Limiting System For Seniors

The Student Affairs Forum at their meeting yesterday received the following proposal from WSG:

"Through the recommendation of the Student Affairs Forum, WSG issued a questionnaire to all women students concerning women's hours. In response to the findings of this questionnaire, WSG would like to amend their proposal of self-limiting hours for senior women.

"WSG proposes the following system of hours for women students of Gettysburg College:

"For Senior women—Self-limiting hours.

"For Junior women — 12 o'clocks during the week and 3 o'clocks on weekends (i.e., Fri. and Sat.). Note: Recognizing that Junior women are not at this time asking for self-limiting hours, but recognizing too that it is foreseeable in the near future.

view Sophomore hours with the authority to adjust them to a maximum limit of automatic 3 o'clocks.

"For Freshmen women—first semester—11 o'clocks during the week and 12:00 Fri. and 1:00 Sat.; second semester — 12 o'clocks during the week and 1:00 Fri. and 2:00 Sat.

"In addition, WSG proposes that visiting restrictions on off-campus apartments be lifted."

After considerable discussion the following motion was made: "That the Student Affairs Committee recommend to the faculty, college administration, and the Student Life Committee of the Board of Trustees—1. That with parental permission Senior curfew be self-limited. 2. That Junior hours shall be 12:00 from Sunday to Thursday, 3:00 a.m.

Friday and Saturday with WSG having the option to recommend any liberalization to the Student Affairs Committee. 3. That Sophomore hours shall continue to be 12:00 Sunday to Thursday, 1:00 a.m. Friday, and 2:00 a.m. Saturday, with WSG having the option to recommend a new system to the Student Affairs Committee. 4. That Freshman hours shall be 11:00 p.m. from Monday to Thursday, 12:00 Friday and Sunday, and 1:00 a.m. Saturday through the first semester then switching to upper class hours in the second semester."

The Student Affairs Committee voted unanimously to adopt this motion. The final section of the WSG proposal which lifted the visiting restrictions in off-campus apartments was also passed unanimously.

Throughout the 20th century Gettysburg women were subjected to parietal hours as part of the college's residence life system—daily restrictions on their comings and goings that no men had to follow. By the late 1960s, many Gettysburg women had had enough. When the college administration was slow to liberalize hours policy, direct action led by Donna Schaper '69, including a sleep-in in the student union in March 1969, helped move Gettysburg towards equality for women.

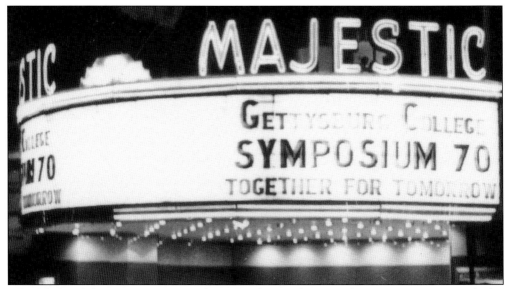

A highlight of the Hanson era—and a sign of Gettysburg students' engagement with the major issues of the day—was Symposium '70. The brainchild of Stephen Nowland '72, Symposium '70 brought leaders in business, the media, politics, and public service professions to Gettysburg for formal lectures and wide ranging informal discussions. To mark the event, United Artists' president David Picker awarded the college rights to a premiere screening of the great Italian director Frederico Fellini's avant-garde film *Satyricon*.

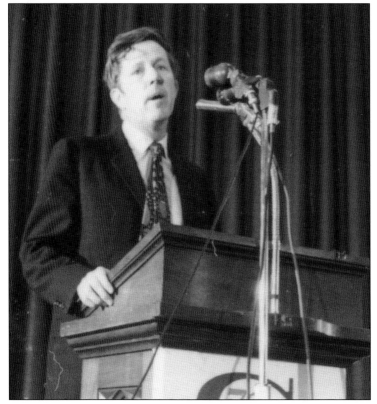

Michael Harrington, author of *The Other America*, was one of many notables who spoke on campus during Symposium '70. Harrington delivered a passionate keynote address to a packed house and later led a seminar in a college residence hall.

A campus antiwar activist, Stephen Warner '68 nonetheless answered a draft call after his first year at Yale Law School. As a military journalist, Warner spent most of a year documenting the everyday lives of GIs in and beyond battle zones—a modern day Ernie Pyle. Killed in action shortly before his tour of duty ended, Warner left his estate to Gettysburg College, including poignant diaries of his Vietnam experience and an extraordinary set of photographs.

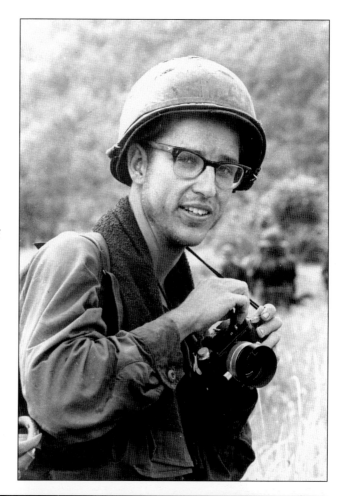

Gettysburg College students were not at the forefront of Vietnam War protests, but they were nonetheless not oblivious to the war. Students regularly debated the war in classes, the college newspaper, and in residence halls. Many of them expressed their opposition to the war by marching periodically to the Peace Light for peace vigils. This photograph is from the silent vigil protesting "the prolongation of the Vietnam War," as a handbill put it, on May 10, 1969.

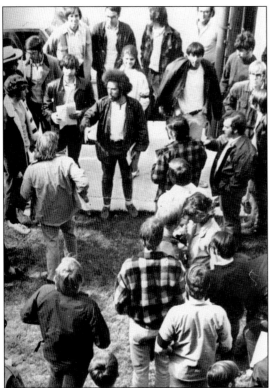

Students protested the Vietnam War in various ways, including boarding buses to participate in the massive rallies in Washington in 1968, 1969, and 1970. Campus protests, meanwhile, were organized by activists like Robert Waldman '70, seen at left, in the center of the crowd.

In May 1970, Pres. Richard Nixon's invasion of Cambodia provoked protests across much of the country, most notably on college and university campuses. At Gettysburg, students marched in protests on campus and joined mass rallies in Washington. Meetings in the SUB were led by Roger Bromley '72 (left) and Thomas Ricento '70 (pictured wearing black armbands).

A musical memory was made in 1970 with the rousing production of *Jesus Christ Superstar*. Skirting the copyright to Andrew Lloyd Webber's score by calling the performances "rehearsals," the college cast—alumni, students, and four faculty members—played to capacity audiences in the chapel over two nights. *Jesus Christ Superstar* was among the most intense and dramatic episodes in a year of high emotion at Gettysburg. John Hylton '72, right, performs an electric dance number.

Cast members carry Jesus (Zane Brandenburg '69) through the chapel at the close of *Jesus Christ Superstar* as the audience responds with a standing ovation.

In October 1970, Dwight Eisenhower's connection to Gettysburg College was recognized by the dedication of a bronze monument sculpted by art professor Norman Annis. Annis and Mamie Eisenhower here flank the statue, adjacent to the Eisenhower Admissions Building on Carlisle Street.

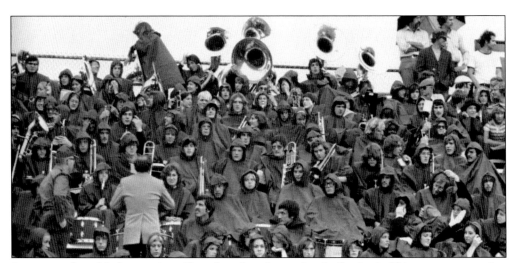

An uncomfortable but stoic college band waits patiently for its halftime cue at a rainy home football game in Autumn 1974. Band director Robert Zellner (back is to the camera at the lower left of the picture) offers instructions to his soggy charges.

Seven

AN AMBITIOUS AGENDA
1977–2007

During his first years as president of Gettysburg College, Charles Glassick (1977–1989) said that his main aim was "learning to cope with the downward slope." By the phrase Glassick meant the anticipated baby bust of the 1980s and the need for liberal arts colleges to downsize if they were to survive.

The irony of Glassick's presidency is that Gettysburg College grew and prospered in the so-called baby bust years. Riding a wave of national prosperity in the 1980s, Gettysburg grew its student body at the same time that it was markedly increasing tuition and fees. Combined with a more aggressive fund-raising program, tuition income enabled Gettysburg during the Glassick years to complete one major new building—Musselman Library in 1981—and renovate virtually all other buildings on the campus. Glassick also expanded the college's curricular offerings, notably interdisciplinary studies; founded a first-rate literary quarterly, the *Gettysburg Review*; and helped carry Gettysburg into the ranks of leading national liberal arts colleges.

In the 1990s, Gordon Haaland (president 1990–2005) built on Glassick's initiatives, particularly in fund-raising and strengthening interdisciplinary studies. Haaland put new emphasis on a wired campus, service learning, and study abroad. By the beginning of the 21st century, half the Gettysburg student body was spending at least one semester studying off campus, hundreds of others were volunteering service in Gettysburg and beyond.

Over the past two decades Gettysburg has grown to a college of more than 2,500 students and nearly 200 full-time faculty, many of whom have earned impressive honors for their scholarship and creativity. A college that once aimed to be a "salutary influence" on the education scene entered the 21st century increasingly confident and ambitious to lead.

Charles Glassick commenced his tenure as president of Gettysburg College in the summer of 1977. A graduate of Franklin and Marshall College and Princeton University, Glassick came to Gettysburg from the University of Richmond, where he had served as vice president for academic affairs. During his 12-year tenure, Glassick raised the college's sights in academics and fund-raising, built a new library, spurred the creation of interdisciplinary programs, founded the *Gettysburg Review*, and earned recognition as one of the nation's 100 best college presidents.

Samuel Schreckengaust '35, chair of the board of trustees, and Charles H. Glatfelter '46, professor of history, are sharing a light moment prior to commencement in May 1977. During his four decades on the faculty at Gettysburg, Glatfelter served as department chair and dean of the college. At some point, he chaired virtually every major college committee. He also wrote a two-volume history of the college, *A Salutary Influence*, published in 1987.

In the spring of 1981, Musselman Library—the first new campus building since McCreary Hall, dedicated in November 1969—was ready for occupancy. Members of the college community joined together on a festive day to hand-carry more than 250,000 books and journals from the old Schmucker Library to Musselman Library. The move went off, according to one observer, "like clockwork."

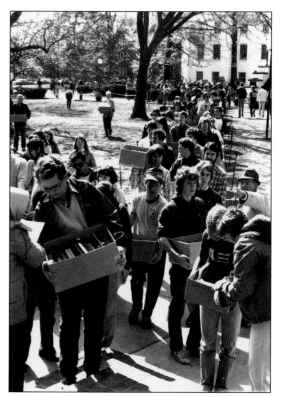

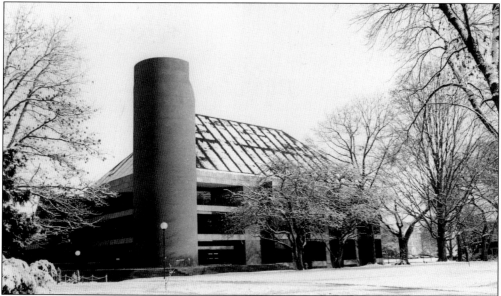

Designed by the prominent Washington architect Hugh Newell Jacobsen, Musselman Library was intended, according to Charles H. Glatfelter, to have "an integrity of its own without offending that of its two imposing neighbors, Pennsylvania Hall and Glatfelter Hall." In this Jacobsen succeeded. The interior has undergone periodic revitalization since its dedication in 1981, as user needs have changed and information technology has become increasingly sophisticated.

Gettysburg's only national championship belongs to the 1980 women's field hockey team, coached by Lois Bowers. Above, Gettysburg women celebrate another goal during that championship season.

Notable visitors to the campus in the 1980s included a future president, George Herbert Walker Bush, shown here responding to a question after a speech in the CUB during his 1980 run for president against Ronald Reagan. Bush failed to stem the Reagan bandwagon in 1980, but he joined forces with Reagan and served as vice president for two terms. He was elected president in 1988.

A pioneer for women's rights at Gettysburg College, English professor Mary Margaret Stewart set a powerfully influential example for generations of Gettysburg students during her 37-year tenure on the faculty, 1959–1996.

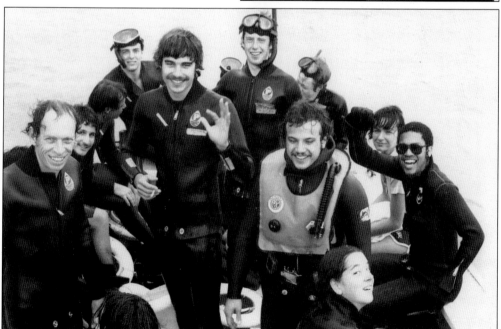

"Barnes, *Invertebrate Zoology*," was a common point of identification for biology students nationwide for several decades. On campus Robert Barnes was known for his high standards, gentle manner, and outstanding teaching. He is photographed here, far left, with Gettysburg marine biology students during the January term around 1981.

Numbered among the college's most distinguished alumni is Michael Bishop '57, winner of the Nobel Prize in Medicine. He is pictured at left on a campus visit in the late 1980s. A respected author as well as a much-honored scientist, Bishop is currently chancellor of the University of California, San Francisco.

Carol Bellamy '63, director of the Peace Corps during the presidency of Bill Clinton and subsequently director of UNICEF, was sworn into her Peace Corps post by supreme court justice Ruth Bader Ginsburg.

In 1987, political science professor Kenneth F. Mott jolted the campus with a motion to abolish the Greek system at Gettysburg College. His proposal was embraced by the college faculty and prompted President Glassick to appoint a special committee to study its implications. The committee backed away from derecognizing fraternities, but under Pres. Gordon Haaland the college put in place a new rights and responsibilities document that addressed issues Mott's motion had originally raised. Notice the satirical T-shirt hanging in the background of this photograph; it was given to Mott by a Greek student as a facetious gesture. (Photograph by William Dowling.)

Gettysburg College Faculty Votes To Oust Fraternities

GETTYSBURG, Pa. (AP) — Saying the Greek system is an outdated bastion of exclusiveness and sexism, faculty members at Gettysburg College are attempting to eliminate fraternities and sororities on campus.

After haggling over the issue for nearly four months, the faculty voted 63-23 to ask President Charles E. Glassick to present the recommendation at the board of trustees' next meeting, May 13 and 14.

Last week, the faculty of Franklin and Marshall College in Lancaster voted to disassociate itself with fraternities and sororities. Colby College in Waterville, Maine, has done away with Greek societies as has Amherst College and Williams College in Massachusetts.

If adopted at Gettysburg, the proposal would affect more than half of the students at this south-central Pennsylvania college. About 1,100 of Gettysburg's 1,900 students belong to one of the school's 12 fraternities or seven sororities, according to B.J. Davisson, assistant dean of student life.

Kenneth Mott, a political science professor who introduced the motion approved the faculty earlier this month, said his proposal had been brewing for years. He said the impetus to call for a ban this year came after an incident last fall in which fraternity students became involved in an "alcohol abuse problem of major proportions." He declined to give specifics.

Davisson said the general feeling among many faculty members is that Greek organizations were outdated bastions of exclusiveness and sexism.

Exclusiveness breeds narrow-mindedness rather than a broadening of the mind, and that, Mott said, is directly opposed to the college's stated mission. He said fraternity and sorority pledges were treated in a "sort of slave capacity," and were forced to run errands, prepare for parties and do things upper classmen did not want to do. Some fraternities also subtly promote a disrespect of women through "primitive macho" behavior, he added.

More FACULTY Page 2

This excerpt from the Associated Press story on the Mott motion to eliminate fraternities at Gettysburg College provides some of the rationale for the faculty action.

Founding editor of the *Gettysburg Review,* Peter Stitt reviews a recent issue of the journal he has edited for nearly two decades. Much honored, the *Gettysburg Review* continues to publish an impressive range of poetry, fiction, personal essays, and cutting-edge artwork. (Photograph by William Dowling.)

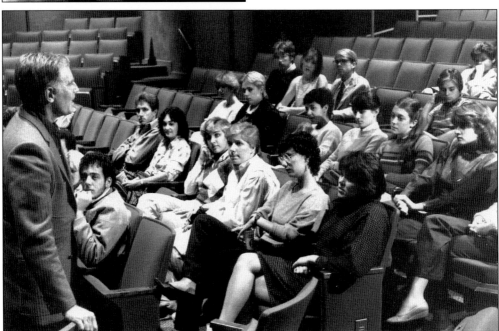

In the fall of 1984, the famed actor Charlton Heston visited campus to participate in a Civil War Institute program that culminated in his recitation of the Gettysburg Address. Heston also spoke with Prof. Emile Schmidt's theatre arts students in the newly renovated Kline Theater.

Marking the Eisenhower Centennial in 1990, the college sponsored a lecture series and two symposia exploring aspects of the 34th president's legacy. Among visitors to the campus were former Pres. Gerald Ford and Ike's occasional golfing partner, the entertainer Bob Hope. Students living in Stevens Hall welcomed Hope by hanging from a third floor window a large sheet inscribed, "Thanks for the memories, Bob!"

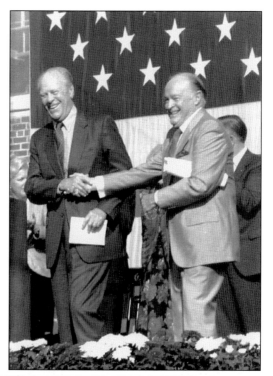

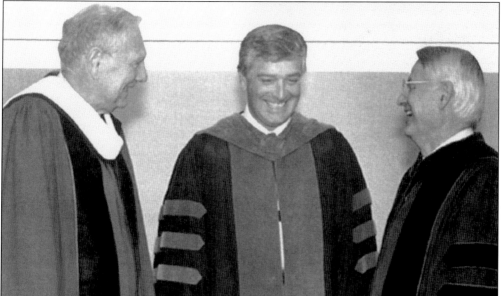

Gordon Haaland was named 12th president of the college in 1990. A social psychologist, he had served as president of the University of New Hampshire prior to arriving in Gettysburg. Haaland advanced the college's information technology, expanded the student body by roughly 20 percent, and strengthened the college's profile. He left office in 2004 having achieved his major goals, including the completion of a $100 million capital campaign. He is shown on his inauguration day, flanked by interim president Charles Anderson, left, and former president Charles E. Glassick, right.

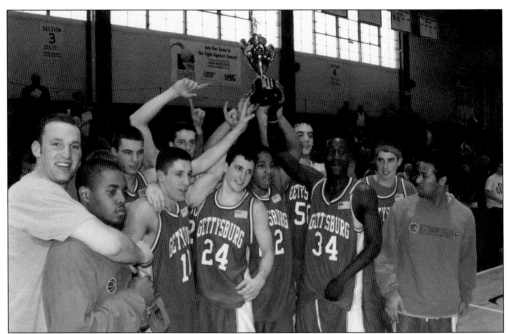

Coach George Petrie's basketball squad celebrates its second consecutive Centennial Conference championship in 2002. Since the Centennial Conference was founded in 1993, Gettysburg teams have won more championships by far than any conference rival—at least 75 championships by the close of the 2005–2006 academic year.

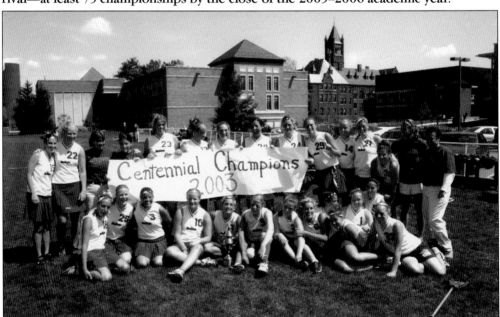

Although men's lacrosse has dominated recent coverage of Gettysburg College sports, the women's squad is also a powerhouse in the Centennial Conference and nationally. Gettysburg women celebrate their 2003 conference championship. Coach Carol Cantele's lacrosse teams have captured Centennial Conference championships five of the past six years, earning automatic invitations to NCAA Division III playoffs.

Since 1990, lacrosse has vied with swimming and soccer as the college's most successful athletic program. Coach Hank Janczyk, shown here with members of a 2001 team that went 6–0 in conference and 13–1 overall, has captured three Middle Atlantic Conference and 10 Centennial Conference championships since assuming coaching duties at Gettysburg College in 1988. Janczyk's teams have qualified for the NCAA Division III playoffs 16 of his 18 years as coach. In both 2001 and 2002, the Bullets advanced to the NCAA finals before falling to Middlebury College.

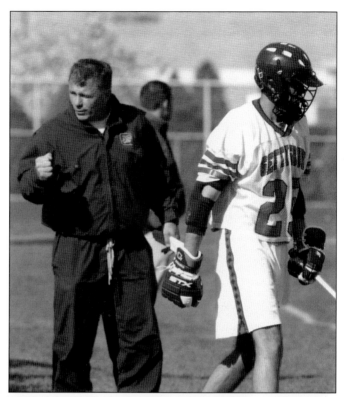

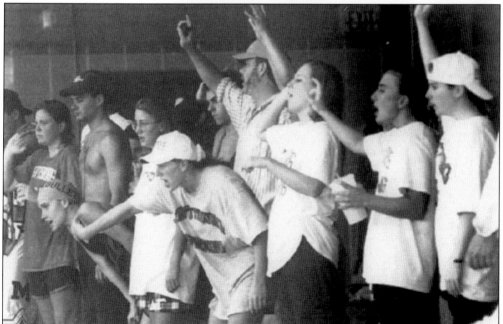

Coach Michael Rawleigh and Gettysburg swimmers cheer on a Bullet competitor in a 1994 contest. Rawleigh's record of 29 conference championships since assuming responsibility in 1985–1986 for men's and women's swimming dwarfs that of any other Centennial League coach. Some 75 of Rawleigh's swimmers have earned All-American honors.

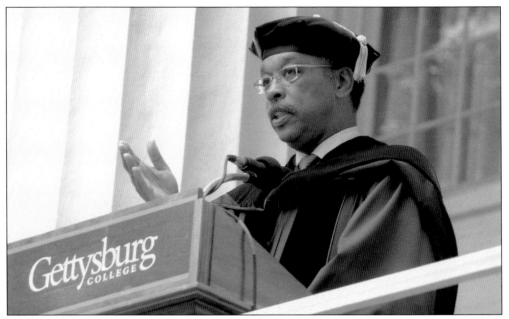

Bruce Gordon '68 has stepped into history as president and chief executive officer of the NAACP, the nation's oldest and most influential civil rights organization. A former executive at Verizon Corporation, during his college years Gordon was a sociology major, a varsity athlete (football), and a member of TKE fraternity. Gordon delivered the commencement address at Gettysburg in 2006.

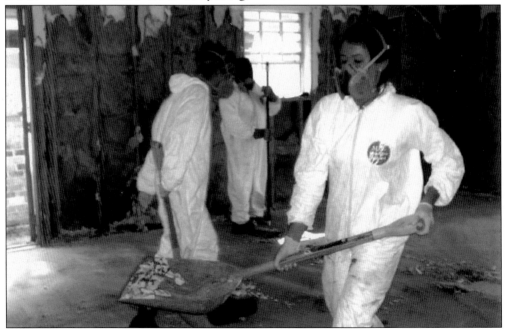

Long a leader in the field of college service learning, Gettysburg continues to demonstrate a deep commitment to service above self. Thirty Gettysburg students and 20 staffers spent their spring break in March 2006 helping clean up homes in New Orleans's lower ninth ward and St. Bernard's Parish that had borne the brunt of Hurricane Katrina.

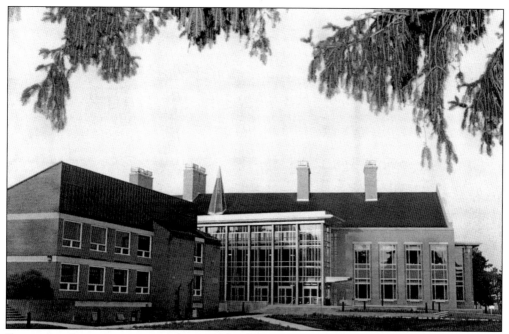

Strengthening science programs and building a state of the art science center was a major priority for Pres. Gordon Haaland. With the help of a Kresge Foundation grant, Haaland was able to accomplish his objective by the fall of 2002. Here is a view of the new science complex shortly after its completion.

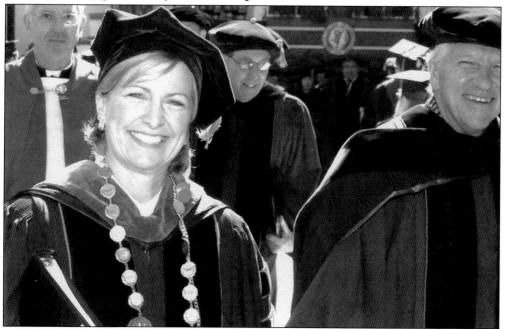

Katherine Haley Will was elected the 13th president of Gettysburg College in 2004. Formerly president of Whittier College in California, Will is the first woman president of the college. She is shown here, foreground, at her inauguration in October 2004. At the right is board chair Charles Widger '67.

A new tradition was established at Gettysburg in 2003. First year students and other members of the college community repeat the walk made by Pennsylvania College students on November 19, 1863, to hear Pres. Abraham Lincoln dedicate the national cemetery in Gettysburg. College admissions officer Joseph Sharrah directs students heading south on Carlisle Street.

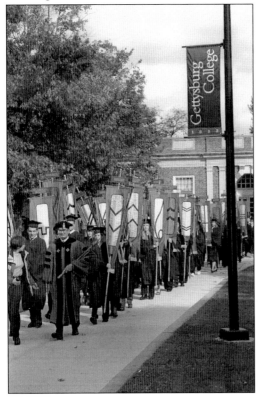

Since 1995, commencement has featured outstanding students carrying banners representing each of the academic disciplines. For Gettysburg graduates, commencement marks what Winston Churchill in another context called "the end of the beginning."